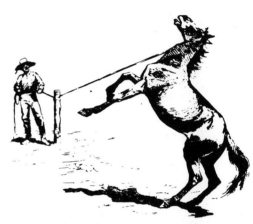

# the illustrations of
# FREDERIC REMINGTON

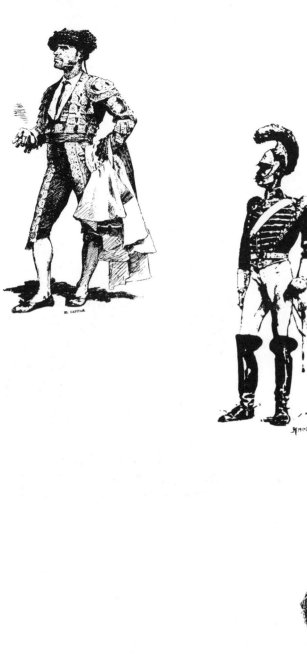

EL CAPITAN.

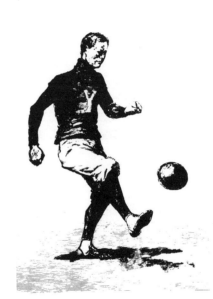

REMINGTON

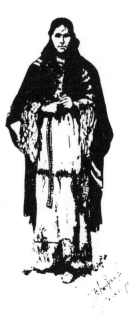

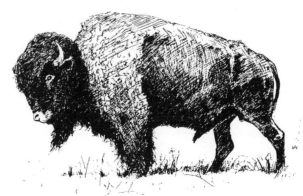

# the illustrations of
# FREDERIC REMINGTON

## with a commentary by
## OWEN WISTER

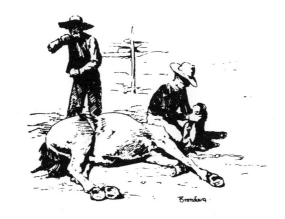

EDITED WITH A CONCISE BIOGRAPHY
AND AN ACCOUNT OF REMINGTON'S WORK AND CAREER BY
**MARTA JACKSON**

**BOUNTY BOOKS** a division of CROWN PUBLISHERS, INC., NEW YORK

# FREDERIC REMINGTON

FREDERIC REMINGTON, pictorial chronicler of the Wild West, is unique in the annals of art. He has managed a miracle to which most artists, if they are truly honest, aspire but rarely achieve: the marriage—in a total, unified body of work by one man—of fine and commercial art. There has probably never been an artist so well known, in his own or any other time, both as a distinguished painter and sculptor on the one hand, and a successful, commercial illustrator on the other.

TRUE, WE HAVE COME TO RECOGNIZE the technique and style of some commercial artists as being worthy of study by the more "serious" students of art; and, certainly, some of our finest painters have dabbled in illustration and in some commercial ventures. But their major output generally places them in one category or the other. However, the qualities and subject matter that ultimately made Remington's reputation are just as evident in his commercial work as in his painting and sculpture. His paintings and statuary have all the realism and story-telling qualities of marvelous illustrations; his illustrations have all the importance, depth, universality, and uncompromising honesty of great paintings. He never once changed his subject matter, always the Wild West, or his theme, life against the omnipresent elements of danger and death, to suit the more sophisticated requirements of the magazines from which he hoped to earn his fortune. Nor would he change a line that he observed to be real or natural to serve the rules of balance or symmetry or decorative design imposed by the academic dictates of the fine arts.

IT IS THIS REFUSAL TO COMPROMISE in any way with reality for the sake of art or anything else that, ironically, makes Remington singularly important as an artist and unquestionably authoritative as a historian. He was a fantastic draftsman who drew and painted without interpretation, except in his eye's choice of what to record. And just as his work was free from interpretation, so was it free from any really distinguishable curlicues or distortions of style, but for characteristically painstaking, nearly three-dimensional details that make his paintings more real than a photograph. This detailed, stark reality gives him both his style and interpretation. Vivid is the sense of life created in his paintings; his economy of purpose answers any questions a work might raise, dramatically and concisely telling his story.

REMINGTON HAS DONE what few other artists have even attempted: he has left a pictorial history of a special time and a special place, not as it might seem to the impressionistic eye, not as the public or other artists would have romanticized it, but as close to an objective view as an individual could come. In this sense, Remington is a naturalist as well as an artist: the volume of notes and excellent studies he was always sketching from life bear very real testimony to this. And, as we have mentioned, he is a historian—generally recognized historian, in fact—of the Wild West. If not for him, we would know less, certainly less of the rich detail, of how that fleeting but vivid moment in our nation's history looked.

THE PERIOD OF THE WILD WEST had an enormous impact on our history. It represents one of the most colorful and exciting times in our past. It has probably given birth to more American legends and folk heroes than any other single time or place in our past. It holds for us, in a new world, the same kind of meaning that Camelot once held for England. And like Camelot, it shone for no more than "one brief moment." It was a relatively short-lived period, and so dangerous while it did exist that it rarely tempted many of an artistic nature (except for writers who will go anywhere) to spend very much, if any, time there. In fact, there were very few living out west in those years who were not born there, running away from something or indulging themselves in some childhood dream of cowboys, Indians, and adventure.

FOR FRED REMINGTON, born October 1, 1861, in Canton, New York, the last reason is probably truest, though perhaps not consciously so at the time. But from earliest childhood, Fred had shown a definite predilection for cowboys, Indians, and, most of all, for horses.

WHILE THERE WERE NO COWBOYS or Indians in Canton, there were horses, and Fred took every opportunity either to ride or draw them. He was always trying to draw something from the time he could manage a pencil, and he filled notebook after notebook with his sketches.

BUT FRED WAS NOT THE SHY, sensitive, solitary child one usually associates with an artistic temperament. He was, in fact, a mischievous, athletic boy, always up to some devilment, and a natural leader when it came to swimming, hiking, riding, or any vigorous activity. He was, however, a terrible student, much to the horror of his mother, Clara.

HIS FATHER, SETH PIERREPONT REMINGTON, founder of the *St. Lawrence Plaindealer* (a newspaper which may still be serving Canton) and a distinguished cavalryman, encouraged Fred's artistic ambitions. His mother, however, was not so agreeable on this subject. She wanted Fred to succeed in a large and worldly way, preferably as a businessman. It was a battle Fred was to wage with her for many years.

AS BAD A STUDENT AS FRED was, and he rebelled mightily and constantly against the discipline and confinement of the classroom, he did manage, in 1878, to enter Yale. He was one of two students to enter the university's brand-new art school. Again, he did not distinguish himself as a student, but, of all things, he did become rather well known as a football player.

IN 1880, SETH REMINGTON died, leaving Fred a small legacy. Free from financial worries for the moment, Fred dropped out of school. He tried several jobs, but he was too restless to keep them very long. Nothing, in fact, really happened and things might have gone on this way indefinitely, had not fate, which sometimes has a way of stepping in to fill vacuums, intervened. It was the summer of 1880, and lovely Eva Caten, from Gloversville, was visiting Canton. Fred, who had shown little interest in girls up to this point, fell immediately and deeply in love. The pretty, bright-faced Eva returned his affection.

THE NINETEEN-YEAR-OLD LAD went at once to Gloversville to ask Eva's father for her hand. But Fred's reputation as a man who couldn't hold a job preceded him, and Mr. Caten, who had it on good authority that Fred would probably never amount to anything, refused.

FRED WAS BEREFT. If he couldn't have Eva, he had to get away from her, preferably to some place where he could make his fortune quickly so he could come back for her as soon as possible.

ORDINARY JOBS, IT SEEMED to him, would not get him the money he needed fast enough. But there were stories of men making vast and fast fortunes out West. And so Fred, nineteen and still a boy, as he would remain in part for the rest of his life, went west.

IT WAS A LOVE AFFAIR from the start. Here were cowboys and Indians and an incredible and varied landscape that he could not resist drawing. And here were more horses than he'd ever seen before.

THE HORSES WERE TO FIGURE most prominently in all his adult works, just as they had in his childhood. In fact, if one had to label all his works under one title, it would likely read, "A Prevalence of Horses." Fred became absolutely expert on them—on their breeds, their temperaments, their habits, their every motion. There has probably never been an artist who could draw the horse with such expertise and life as Remington. Apocryphal, in the face of much expert criticism, is his long-lived insistence on showing a horse running with all four feet off the ground. Later, instant photography would prove what Fred's incredible camera eye had already noticed: Horses did gallop with all four feet in the air.

THE REVELATION DID NOT EXCITE FRED. A reasonably modest fellow in general, he was sure of his knowledge of horses. He had written proudly about himself: "He knew horses," and he wanted this for his epitaph. They would remain his abiding interest, next to Eva, for the rest of his life.

BUT HE WAS ONE COWBOY who loved his girl even better than his horse, and in these early days in the West, he missed her horribly. Though he had found a wealth of material for his hungry eye and prolific pen, by 1884, Fred, who had tried ranching, prospecting, and business investments, had not made a cent, much less a fortune. Nevertheless, he decided to go back home for Eva. Since it was obvious she would have no one but Fred, anyway, her father let them marry, and the young couple went back west.

THE ROUGH LIFE and precarious finances had "Missy," as Fred called her, back East in a year. Fred's mother went west to persuade him to do likewise, but by now he had identified, at least in part, his goal. From the time he had arrived in that wilderness, he'd been told by the old-timers that the Wild West was constantly shrinking. Even then, it was apparent that the railroads, banks, businesses, settlements, and all the trappings of civilization were moving relentlessly toward the Pacific. The Wild West had begun disappearing from the day it was born,

and now it had, as Fred put it, "a thirty-day note" on it. He wanted to record its moment in history before civilization collected its note and turned the West into something else. So he continued, as he had before, wandering through the land, prospecting among Geronimo's Apaches, living at Army posts near Indian reservations, falling in love with the Comanche's pinto ponies, making a fantastic collection of Western accouterments, and drawing, drawing, drawing.

IN 1885, STILL MISSING EVA and tired of being poor, Fred went to New York City to try to sell some of his work. Missy joined him there, and he began a year of round-making and rejection that was almost as financially futile as his whole life had been up until this point. True, he had already sold some of his work: several paintings in Kansas City and two very rough sketches to *Harper's Weekly* in 1882. But that was just about it, and the sketches were so rough they had to be redrawn by a staff artist before they could be printed. The credit line for one of them stated: "Drawn by A. W. Rogers from a sketch by Frederic Remington."

HARDLY A PERSONAL TRIUMPH, THE SALE did open doors at *Harper's,* and finally, after a year, they rekindled their interest in Fred's work. On January 9, 1886, Remington's first picture to be published under his own name appeared in that magazine. It was "The Apache War—Indian Scouts on Geronimo's Trail."

THIS WAS THE TURNING POINT. His pictures began appearing regularly in *Harper's Weekly,* as well as in *St. Nicholas* and *Outing Magazine.* The orders for his work came faster and thicker, and there was nowhere for Fred to go but up—financially and artistically.

BUT FRED DID NOT FORGET his beloved West in the hectic pace of earning fame and fortune. Not only did he continue using it as the sole subject of his work, but every year, for nearly the rest of his life, he spent three months, either on vacation or assignment, out on the western plains, prairies, and deserts. And in 1890, after he had won even greater success, he witnessed the final chapter in the Indian uprisings. It was in the Dakota Badlands, where wily old Sitting Bull was leading the Sioux in their last serious stand against the Army and the white man. It was really the death of the Wild West, and it was fitting that Remington should be there.

MEANWHILE, EXCITING THINGS were happening back in New York. In 1887, his paintings were chosen for exhibition by the American Water Color Society and by The National Academy. In 1888, he illustrated Theodore Roosevelt's *Ranch Life and the Hunting Trail,* at that famous man's request. He and Teddy became fast friends, and it was at this point that he also received the friendship and admiration of Owen Wister, father of the Western novel.

IN 1890, HE ILLUSTRATED LONGFELLOW'S *The Song of Hiawatha,* which established him once and for all as a top artist and illustrator. But if the poem helped make Remington, there are those who think his illustrations helped make the poem.

IN 1893, REMINGTON had a one-man exhibit. Though the show consisted of work he had used for illustration, it was, nevertheless, a bid for recognition of these illustrations as fine art, and a step from illustrator to fine artist in Remington's mind, if nowhere else. The show was not a spectacular success, though it was far from a flop, and it did serve notice of Remington's direction.

AT THIS POINT, REMINGTON tried his hand at writing. Though he had done several magazine articles and nonfiction material (expressing himself rather gracefully and well), he now decided to write a romantic Western novel. It was called *John Ermine of the Yellowstone,* and a beautiful heroine and love-interest figured prominently in it. This presented Fred with one problem. Though he had drawn some women, he did not like to do so, and probably figured he couldn't do it well enough to suit himself, his heroine, or his public. So he hired another illustrator, one as popular as himself and probably the leading portrayer of womanly loveliness of all time —Charles Dana Gibson.

THE NOVEL WAS A MODERATE SUCCESS, but Remington went back to his art work, and in 1895, he took his first real step away from illustration. He began to sculpt. Because his drawings had such a three-dimensional quality—he visualized everything from all angles as he drew —sculpting came naturally to him. His first work was "The Bronco Buster." A limited number were cut in bronze, and the statue was tremendously successful, selling even then for high prices. His work in this medium improved steadily, and in 1902, he did his most famous statue, "Coming Through the Rye."

IN 1903, *COLLIER'S*, THE MOST DISTINGUISHED magazine of the period, freed Remington from the constrictions of illustration. It gave him a contract that guaranteed him a certain amount of money, offering him the freedom to paint what he pleased, provided the magazine had the option to print it. In return, Fred was also to have his paintings returned to him once they had been reproduced. "Fight Over a Water Hole" was painted under this contract.

THE *COLLIER'S* ISSUE OF MARCH 18, 1905, was published as the Remington number. This was devoted not only to the works of Remington himself; it also contained many critical essays and tributes to his artistry. There was no doubt that Remington was well on his way to being considered an artist of note as well as an illustrator, no matter what controversy raged over him in the minds of the guardians of our culture. For even then, as today, there were those who would argue endlessly about which category Remington really falls into.

BY 1909, REMINGTON had actually achieved all his goals, though he was by no means ready to stop working. He had set down the history of the West in pictures, was financially successful, and was known even among the critics as a "... notable painter and sculptor of which the nation can boast..." and "... one of the revolutionary figures in our art history..." He painted "The Love Call" and "Big Horn Basin" that year, and completed "The Stampede," considered by many to be his finest piece of sculpture. Early in December, there had been an exhibition of his works at Knoedler's in New York City, and the show turned out to be a critical and financial success.

ON DECEMBER 20, 1909, FRED REMINGTON went to bed with severe stomach pains. The day after Christmas, he was dead. He was forty-eight years old, but he had lived enough for four men. Were his life to be arranged event by event, adventure by adventure, success by success, it would have extended to the average eighty-year-old's—and beyond.

MARTA JACKSON

# COMMENTARY by Owen Wister

IF ANY ONE asked you to tell them what George Washington looked like, you would be able to do so very readily if you have any powers of description; for you have had a great many opportunities to see pictures of George Washington, to say nothing of the likeness that every day must bring you on our postage stamps.

BUT DO YOU KNOW the look and bearing of the private soldier whom he led to battle? Have you in your mind an instantaneous picture of the Continental troops, say at Valley Forge? Could you tell how a sergeant looked as distinguished from a private? Have the painters or draughtsmen of our Revolutionary days gone into this subject with sufficient attention and vividness to tell you as much about George Washington's troops as they have told you about George Washington? I do not think that they have.

HOW VERY DIFFERENT AN IMPRESSION of our American soldiers of today has the work of Frederic Remington given us! How well we all know the look of Remington's sergeant, the look of Remington's private! How our eye has been educated by Remington to perceive and note the differences between the trooper and the infantry soldier! For Remington with his piercing and yet imaginative eye has taken the likeness of the modern American soldier and stamped it upon our minds with a blow as clean-cut as is the impression of the American Eagle upon our coins in the Mint.

OUR GENERALS WILL SIT for their portraits as Washington and William Penn sat for theirs; but never until this particular day have we possessed a recorder who should give also to posterity the enlisted man to be put alongside with the captain that led him into battle. How much more rich the past would be for us if various Remingtons, each in his day, had handed such work down into our sight! We should then know not only the face of William Penn, but the faces also of those Indians who stood and made treaty with him. We should not only know how Oliver Cromwell looked, but we should have a clear conception of that stern expression which the Puritan battalions wore. We should not only recognize Columbus as we walk through some gallery or turn the leaves of some album of engravings, but we should also know what look of daring, not unmixed with superstitious awe, was on the faces of the men who sailed the ships at his command from the old world to the new. But none of this we can ever know. Our heritage in portraiture includes the leaders of men; it does not include the men themselves. No artist until Remington has undertaken to draw so clearly the history of the people.

IS IT NECESSARY to mention the other things that Remington stands for? This is surely enough; but he stands for certain other things, both great and definite. He has pictured the red man as no one else, to my thinking certainly, has pictured him. He has told his tragedy completely. He has made us see at every stage this "inferior" race which our "conquering" race has dispossessed, beginning with its primeval grandeur, and ending with its squalid degeneration under the influence of our civilized manners.

NEXT, WHILE RECORDING the red man in this way, Remington has recorded the white man who encountered him—recorded this man also in every stage from dignity to sordid squalor. Pioneers, trappers, cowboys, miners, prospectors, gamblers, bandits—the whole motley rout goes ineffaceably into Remington's pages.

AND, FINALLY, he has not forgotten nature herself. The mystery of the untouched plains and the awe of the unscaled mountain heights have been set down by him not only truthfully, but with potent feeling and imagination.

REMINGTON is not merely an artist; he is a national treasure. And if ever it should occur to the not always discerning minds of academic institutions that Remington should be crowned at their hands, I should like to hear him receive his degree in these words: "Frederic Remington, Draughtsman, Historian, Poet."

## "He Knew Horses"

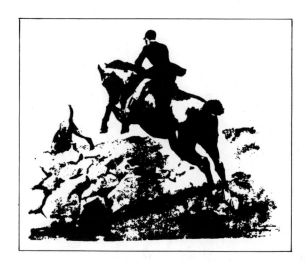

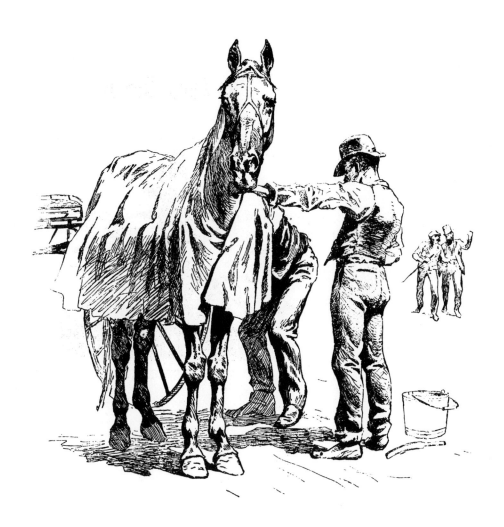

READY FOR A HEAT

14

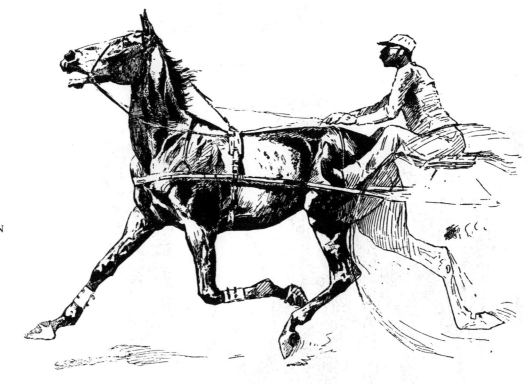

WARMING UP—A STUDY OF ACTION

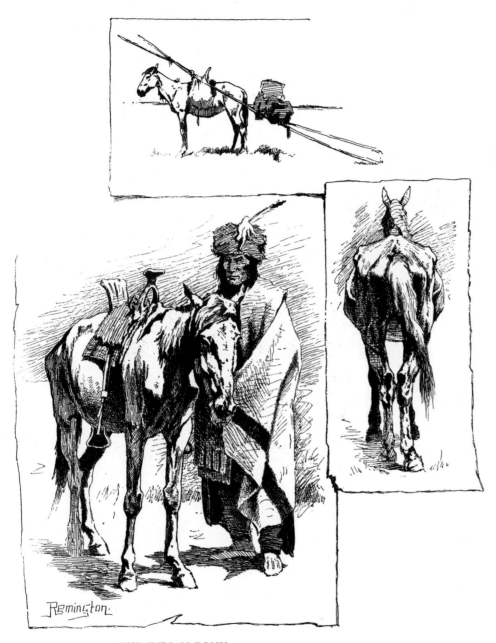

THE INDIAN PONY

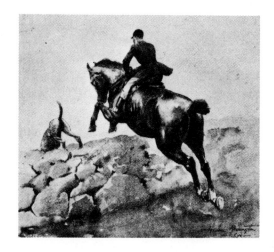

CUTTING OUT THE WORK

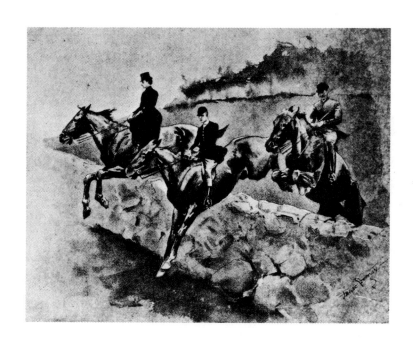

A STIFF WALL

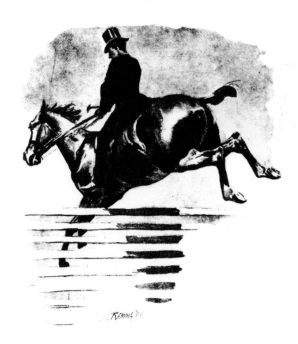

JUMPING HORSE

POLO IN AMERICA

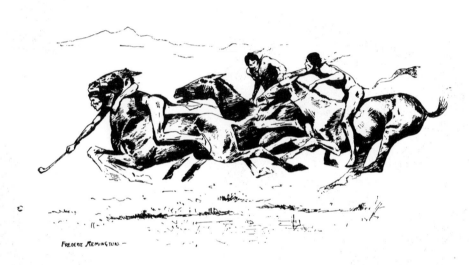

THE GAME AS PLAYED BY AMERICAN INDIANS

JAMES GORDON BENNETT AND THE PIONEER PLAYERS OF 1876

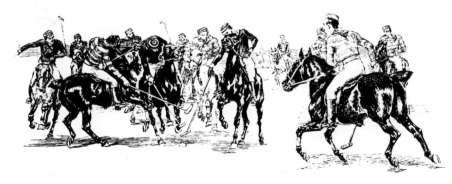

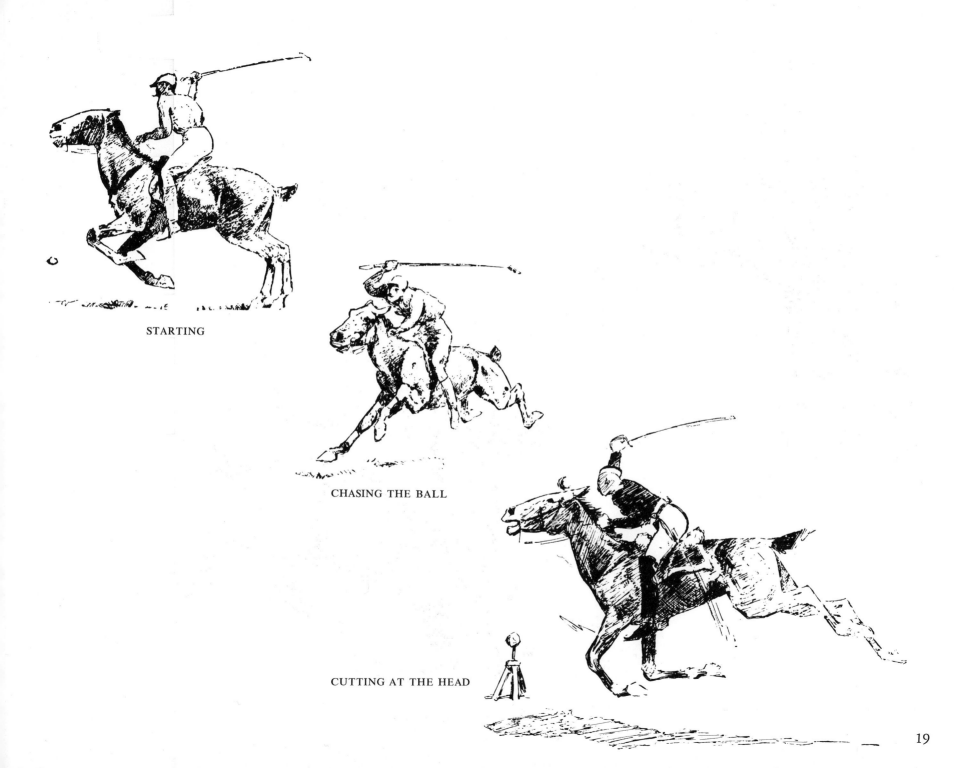

STARTING

CHASING THE BALL

CUTTING AT THE HEAD

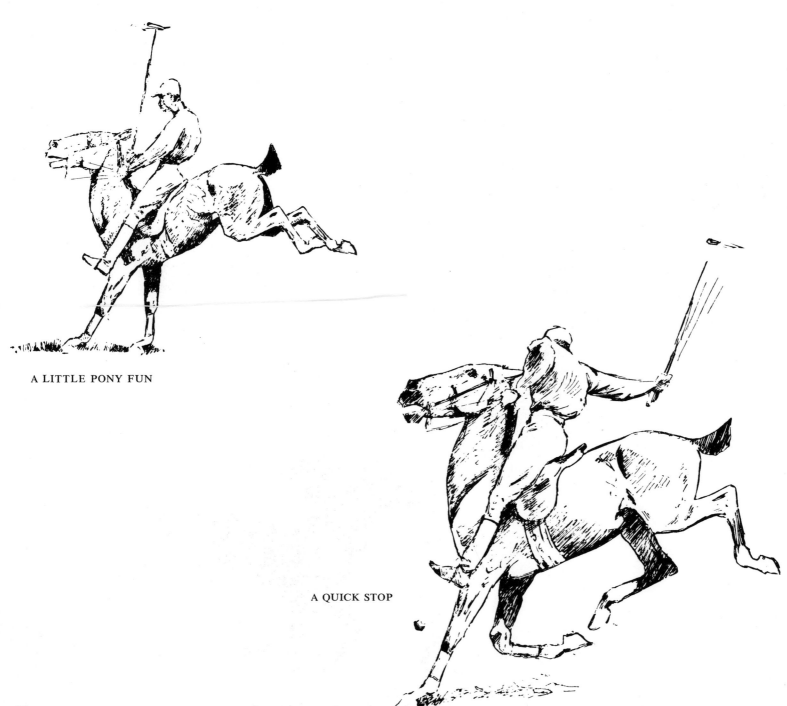

A LITTLE PONY FUN

A QUICK STOP

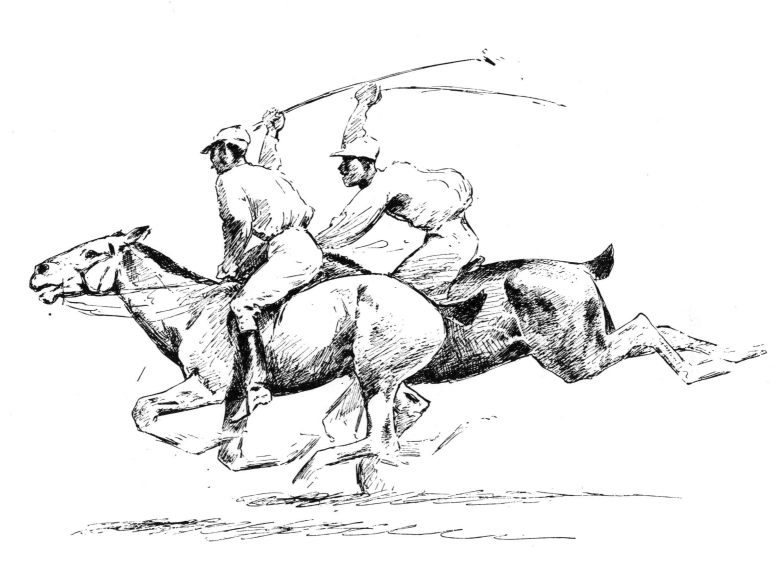

A DASH IN THE POLO GAME

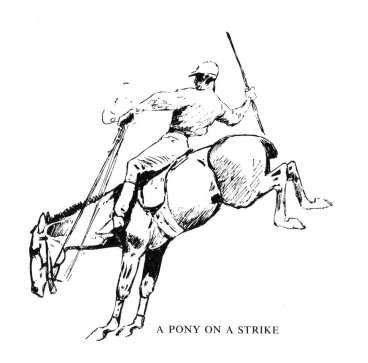

A PONY ON A STRIKE

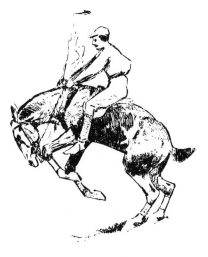

A BUCK JUMPER

POINTING THE RING

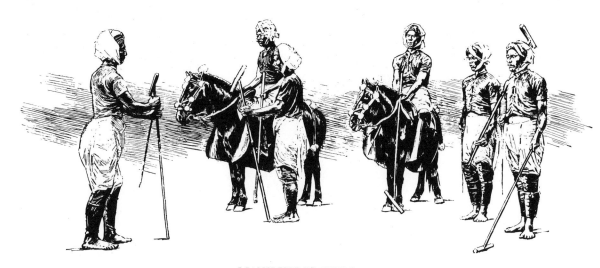

MANIPURI PLAYERS

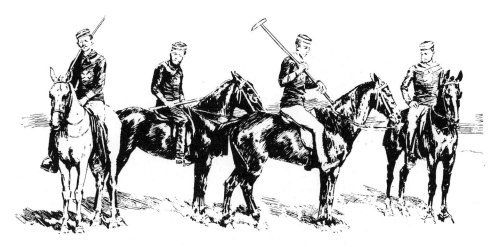

THE BRIGHTON POLO CLUB OF 1877

A SKETCH ON THE GROUNDS

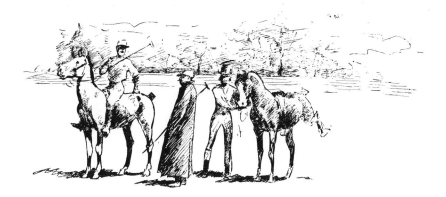

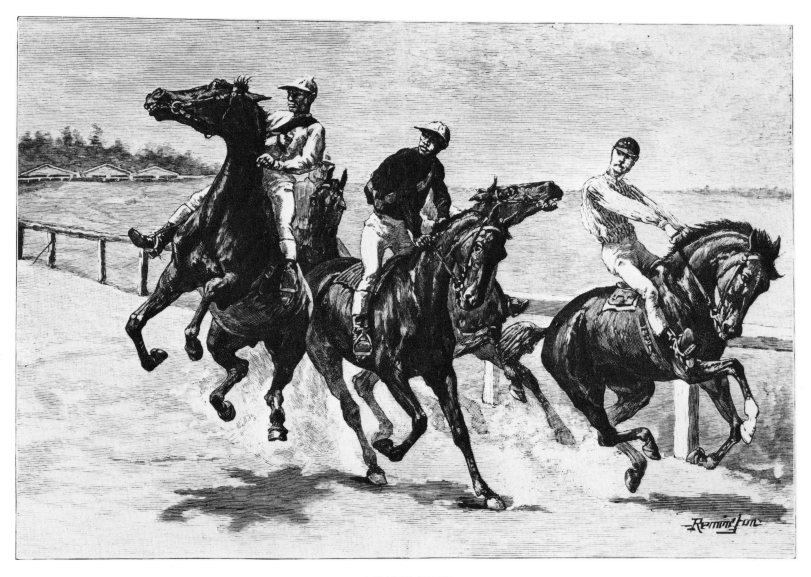

A FALSE START

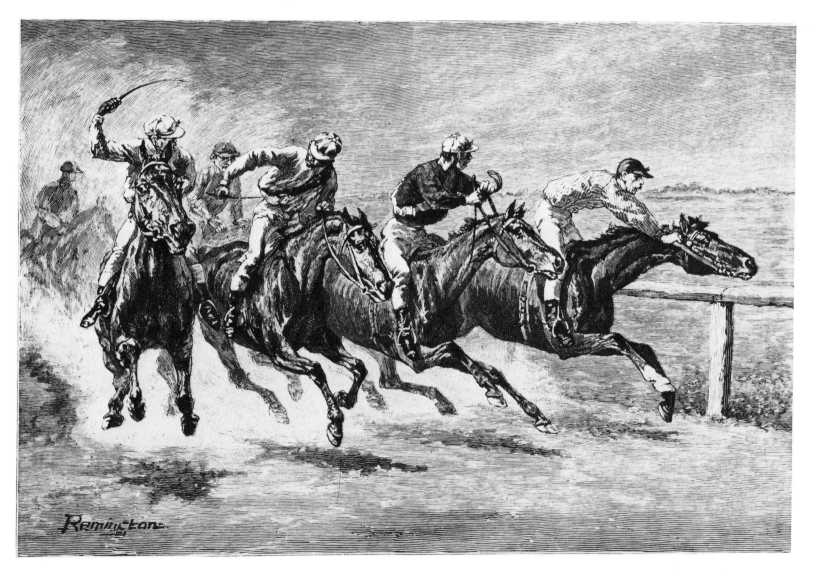

A CLOSE FINISH

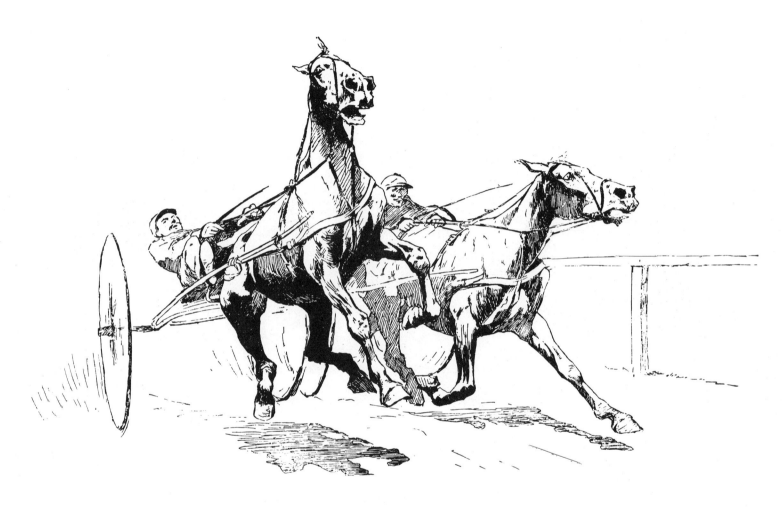

A BREAK

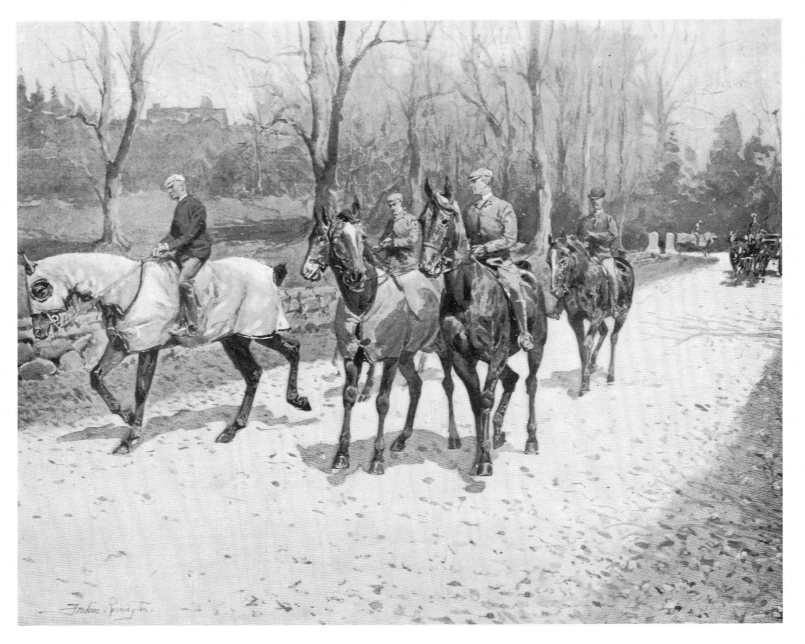

GOING TO THE HORSE SHOW

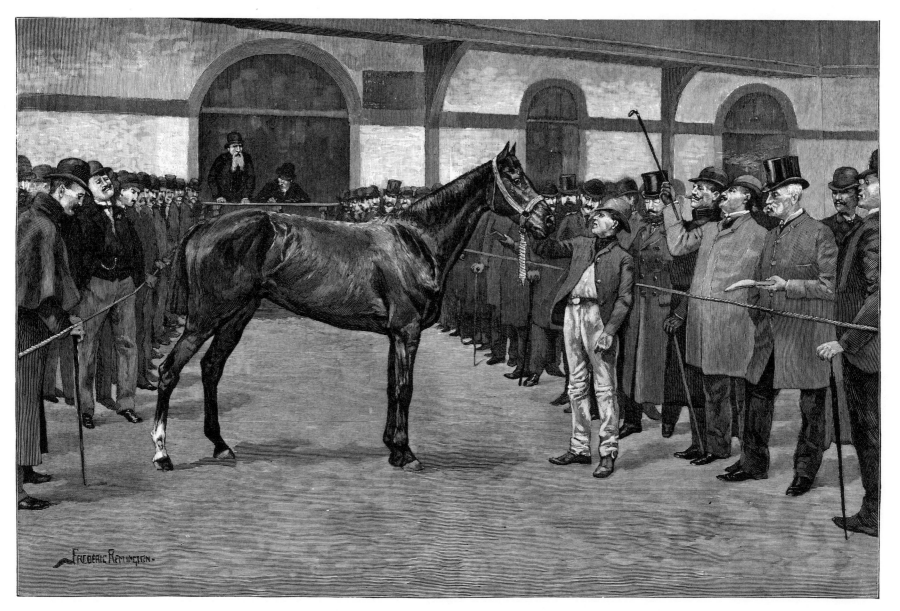

AUCTION SALE OF BLOODED STOCK  AT THE AMERICAN HORSE EXCHANGE, NEW YORK

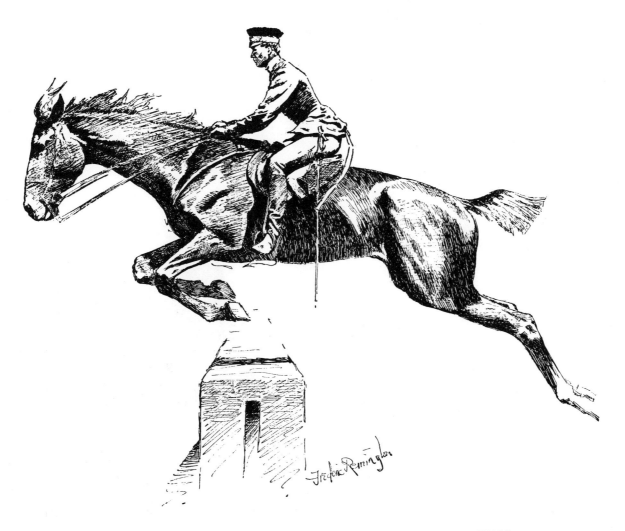

GERMAN RIDING-SCHOOL STUDENT JUMPING BRICK WALL

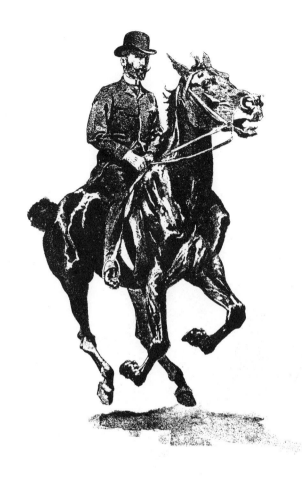

ON THE BRIDLE PATH,
CENTRAL PARK, NEW YORK

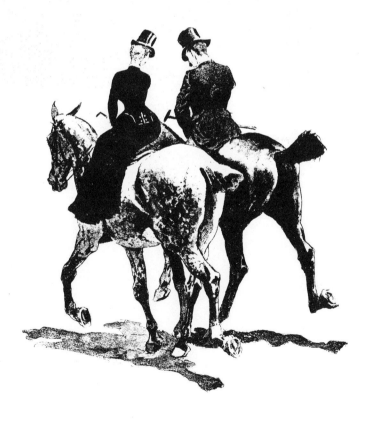

30

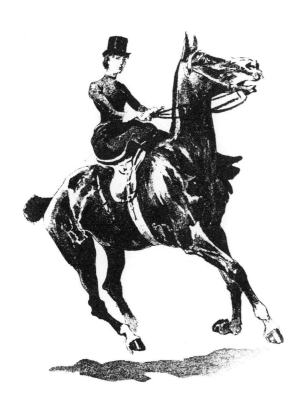

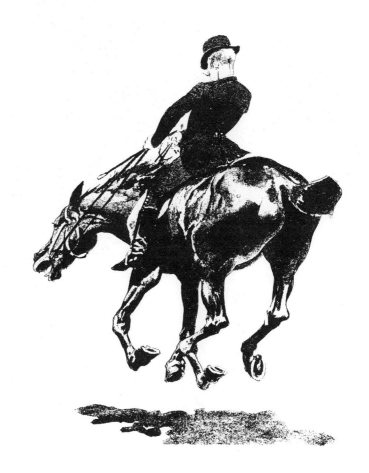

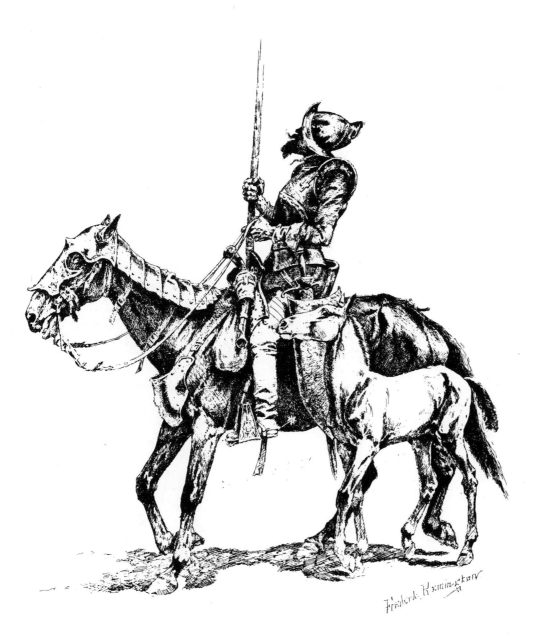

THE FIRST OF THE RACE

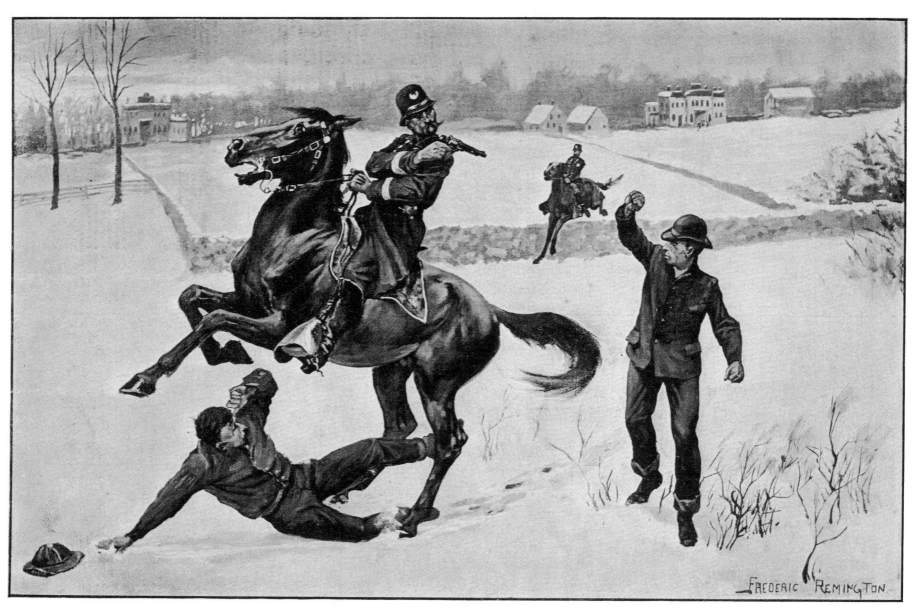

MOUNTED POLICEMEN ARRESTING BURGLARS UPTOWN IN NEW YORK

33

NORMAN PERCHERON

WHIPPING IN A STRAGGLER

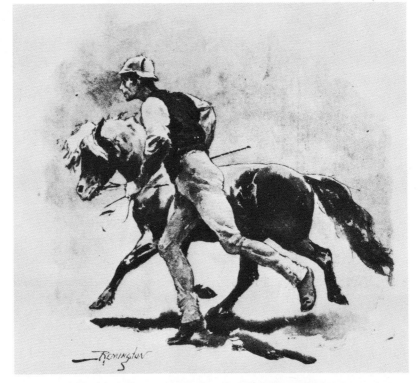

SHETLAND PONY

34

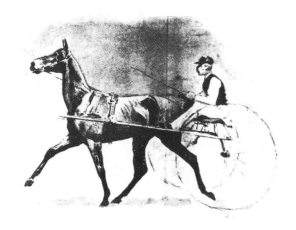

TROTTING HORSE

MARE AND COLT

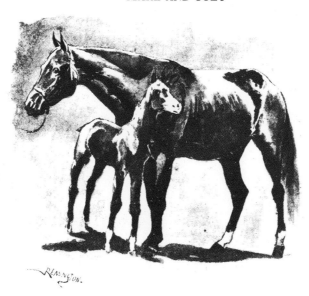

POLICE STOPPING RUNAWAY

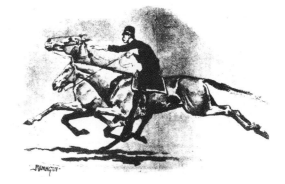

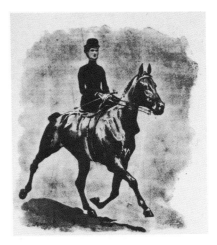

LADY RIDER

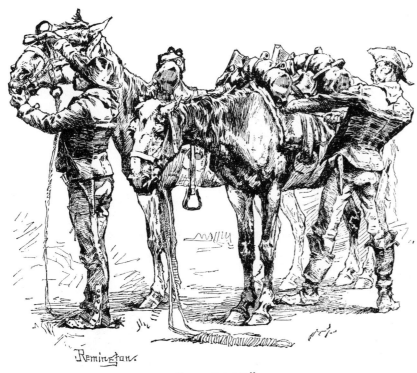

"SADDLE UP"

READY FOR THE FRAY

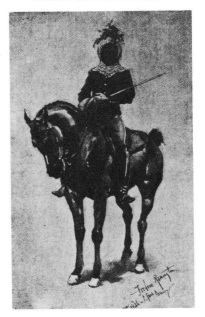

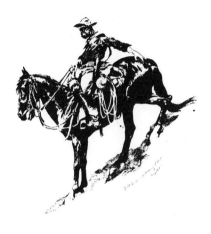

A STUDY OF ACTION

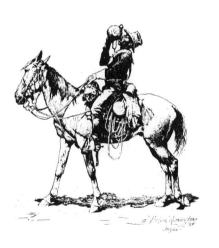

A PULL AT THE CANTEEN

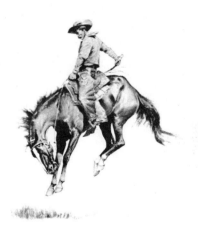

A "SUN FISHER"

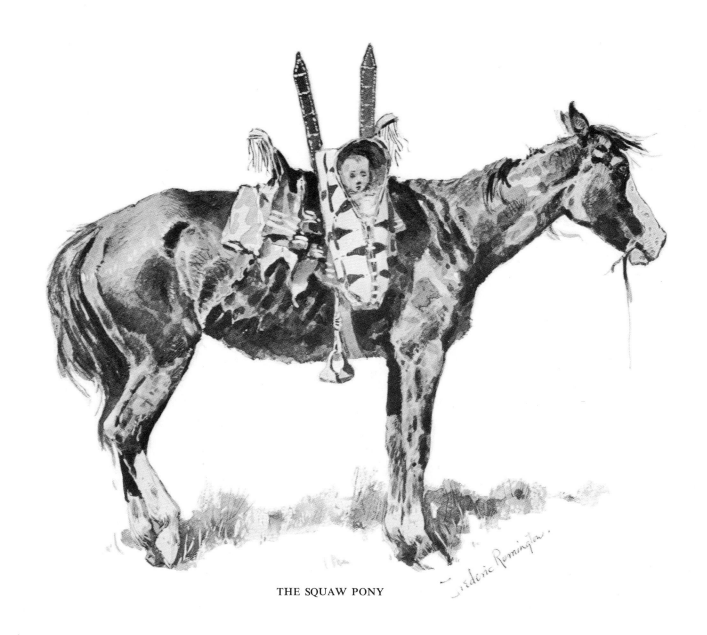

THE SQUAW PONY

# Football

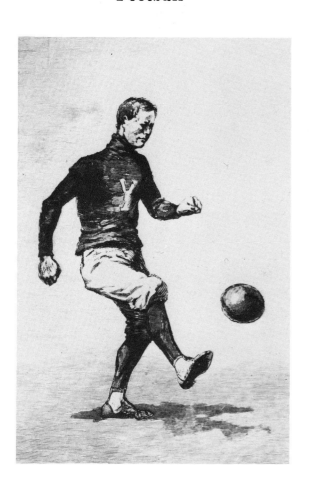

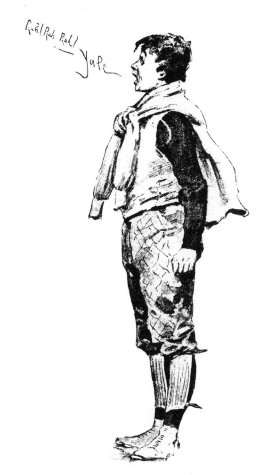

THE COCK CROWS

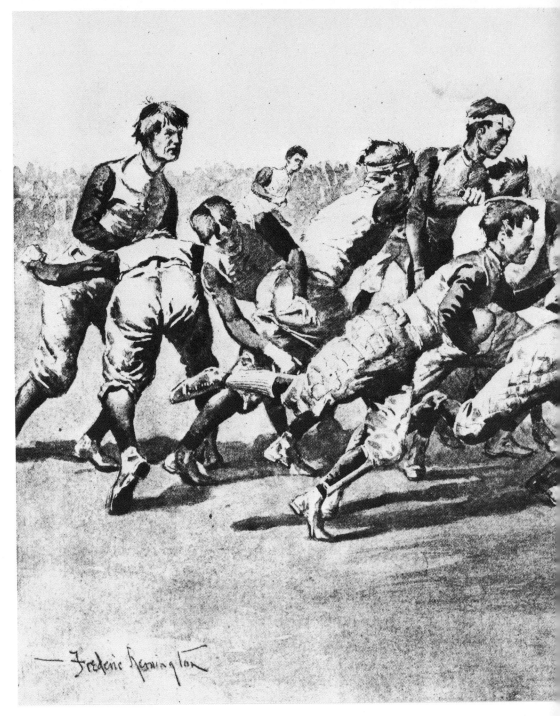

A RUN BEHIND INTERFERENCE

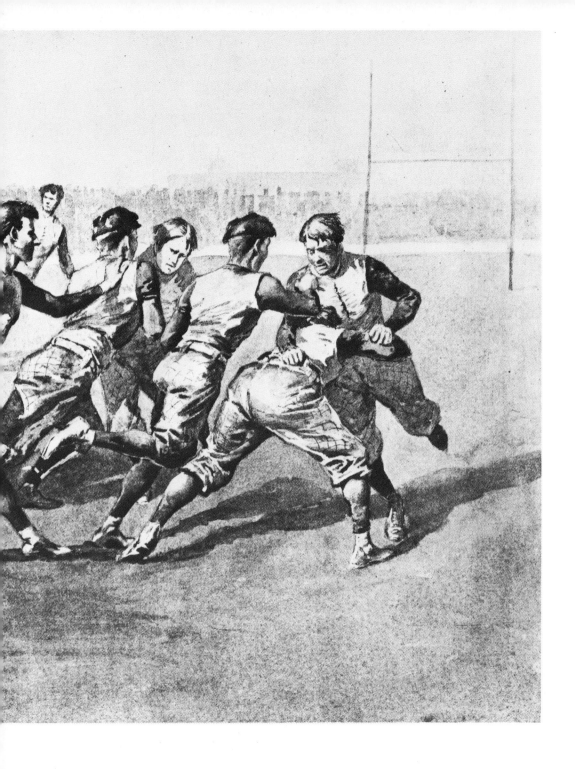

A BIT OF ADVICE

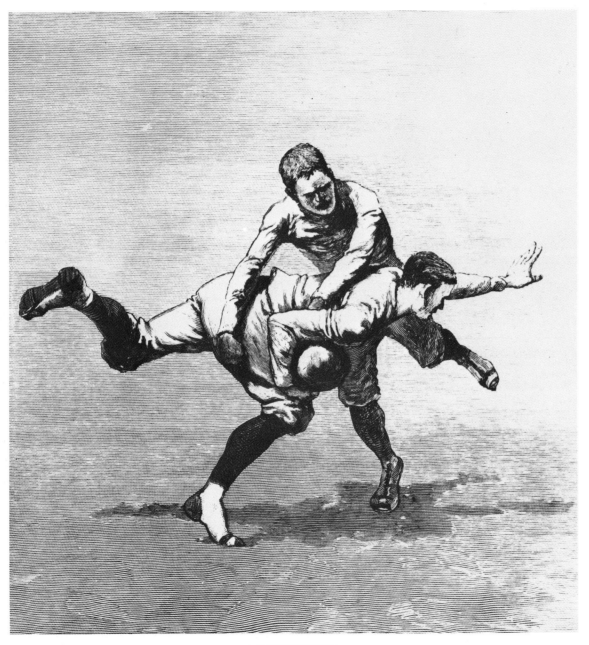

A LOW RUNNER

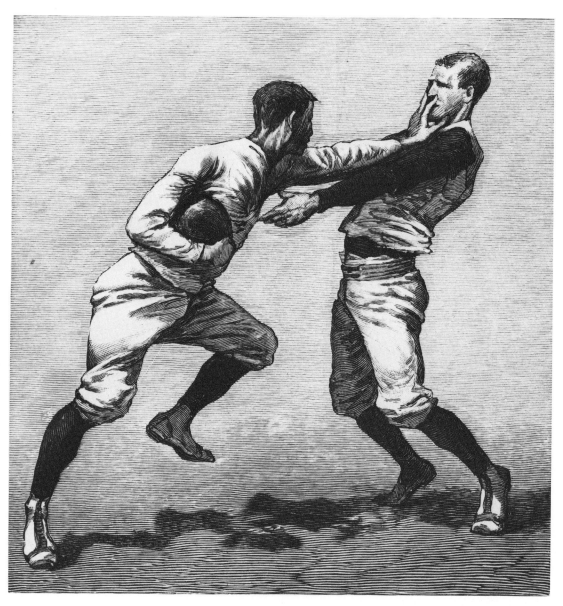

BRUSHING OFF

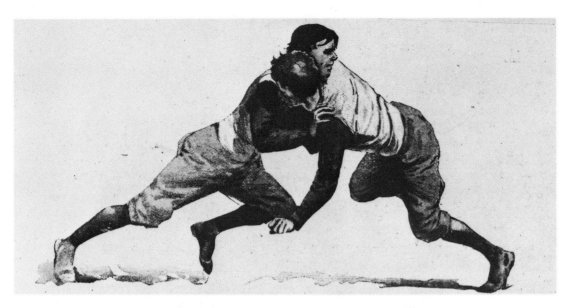

BLOCKING

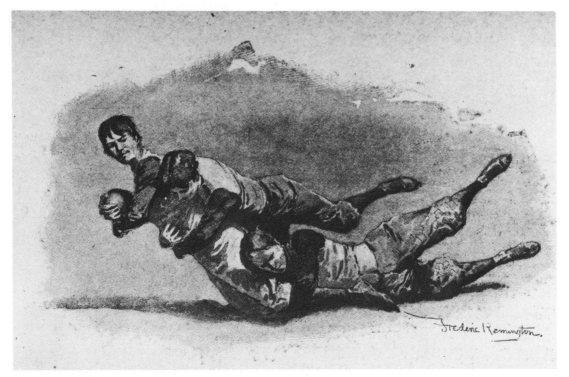

A GOOD TACKLE

44

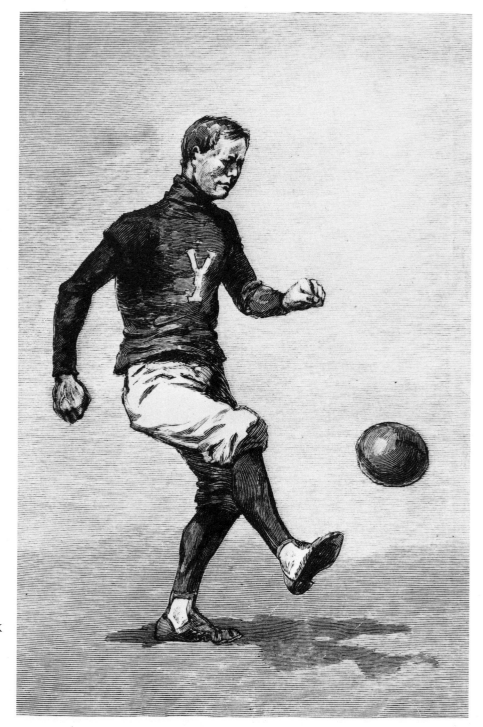

THE DROP-KICK

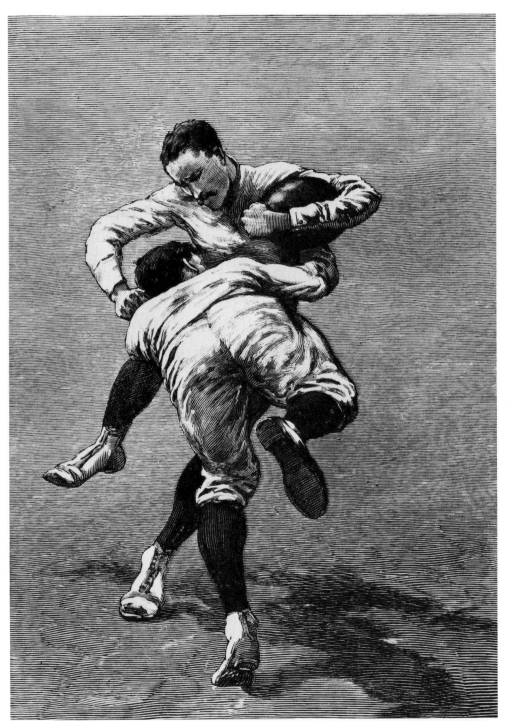

A LOW TACKLE

A LONG PASS

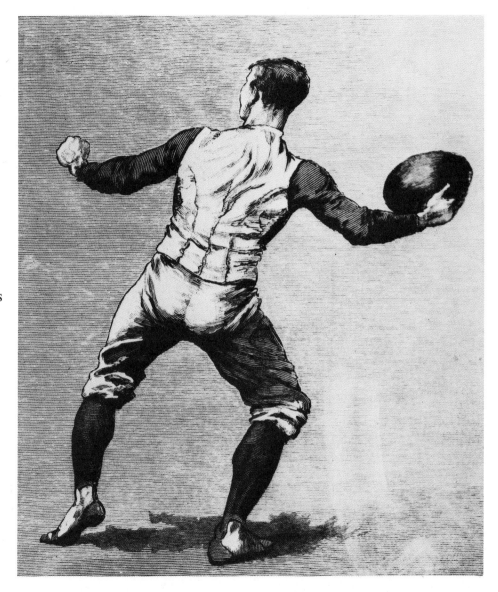

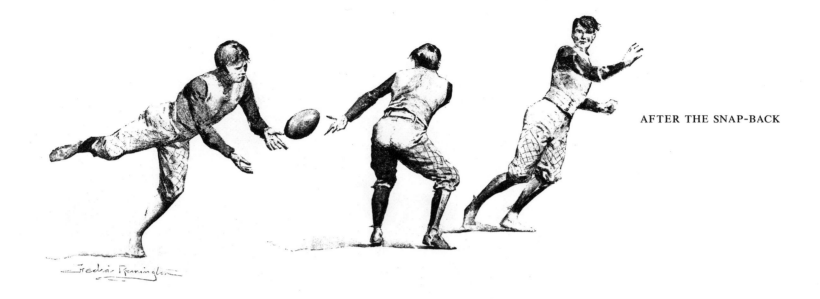

AFTER THE SNAP-BACK

FOOTBALL ARMOR

RUBBING DOWN IN THE GYMNASIUM

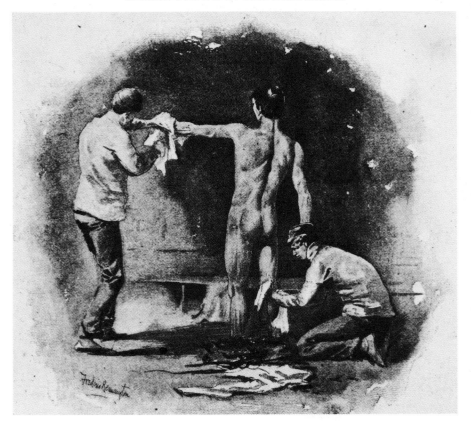

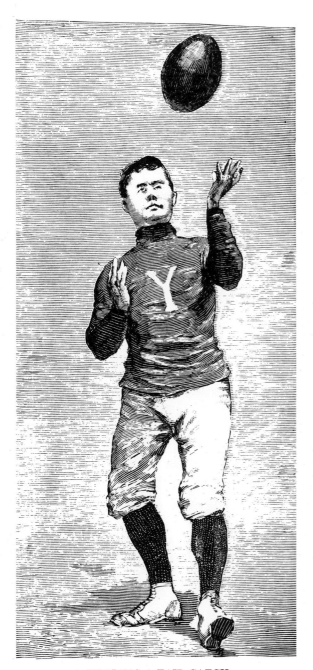
HEELING A FAIR CATCH

49

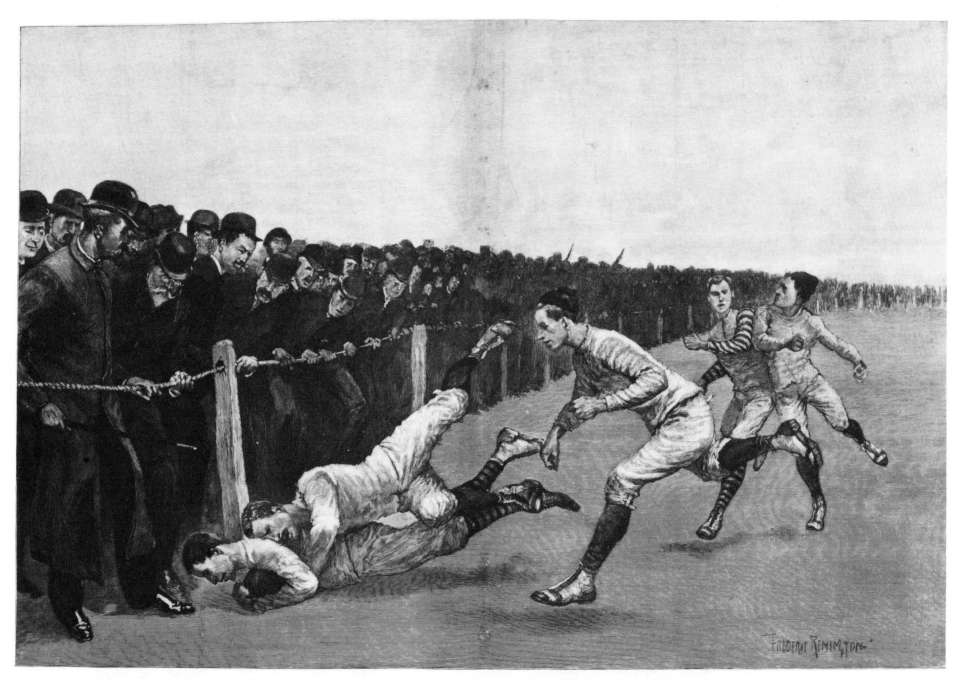

**FOOTBALL—A COLLISION AT THE ROPES**

# Fishing and Hunting

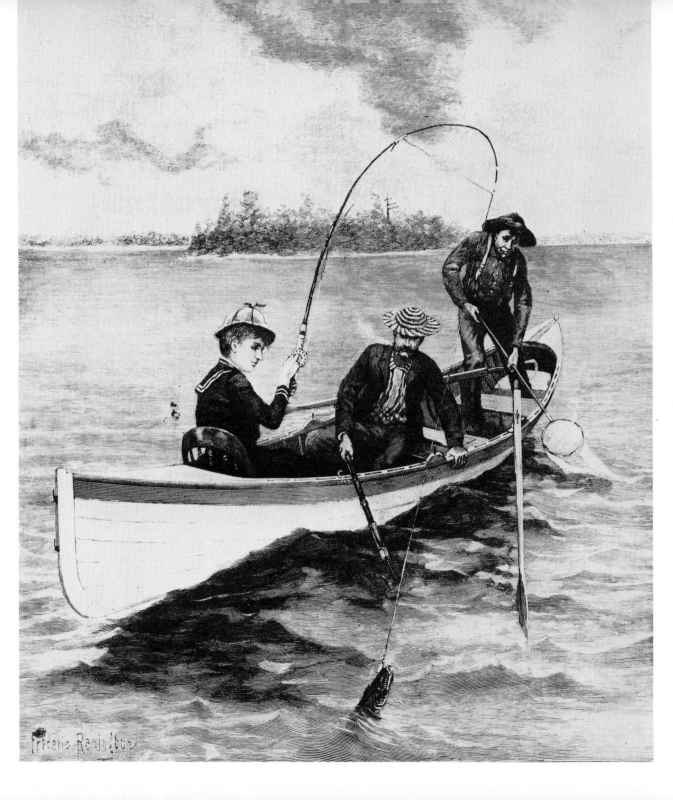

HER FIRST MUSKALLONGE

IN FISHING TIME

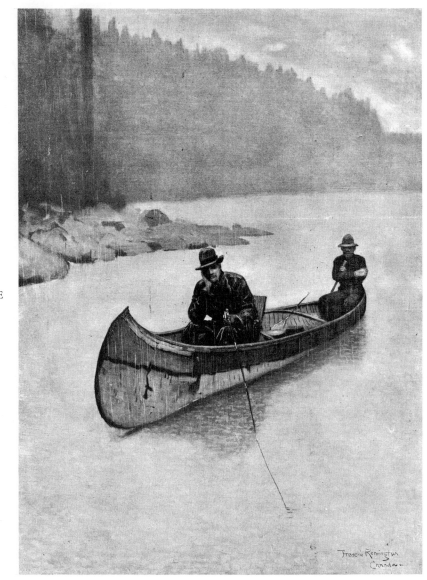

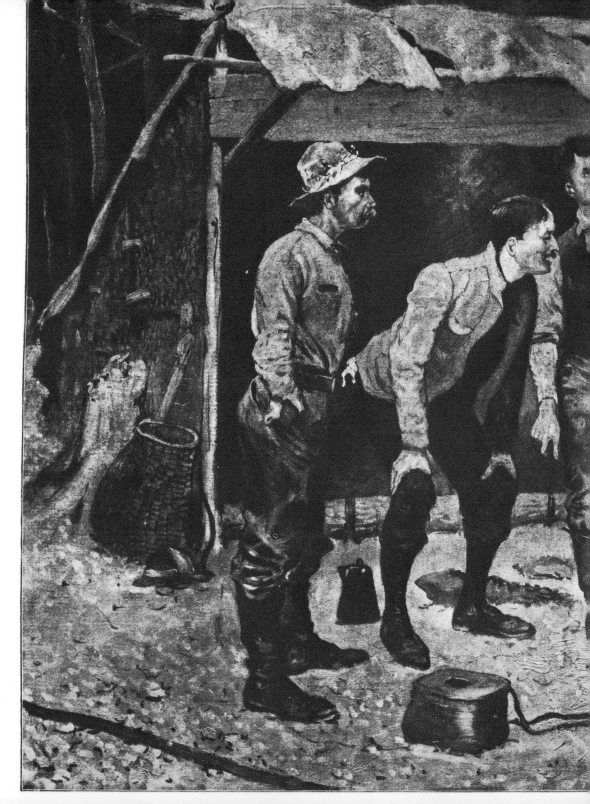

SPRING TROUT-FISHING IN THE ADIRONDACKS—
AN ODIOUS COMPARISON OF WEIGHTS

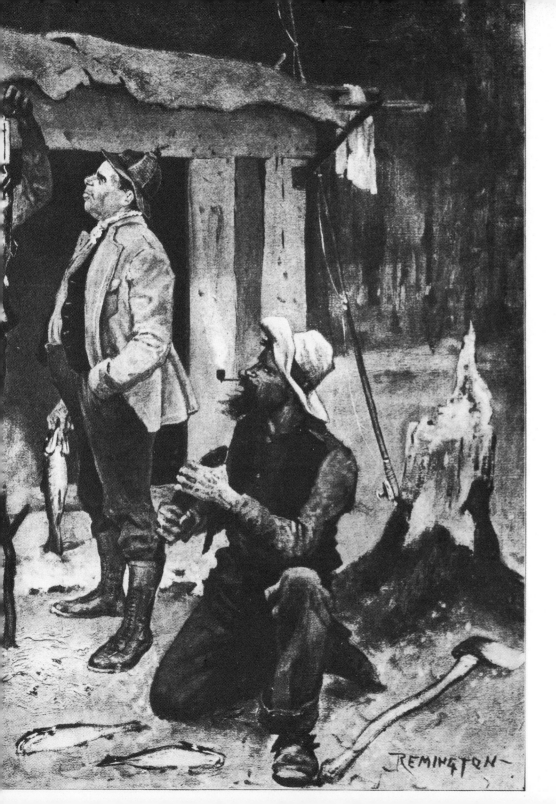

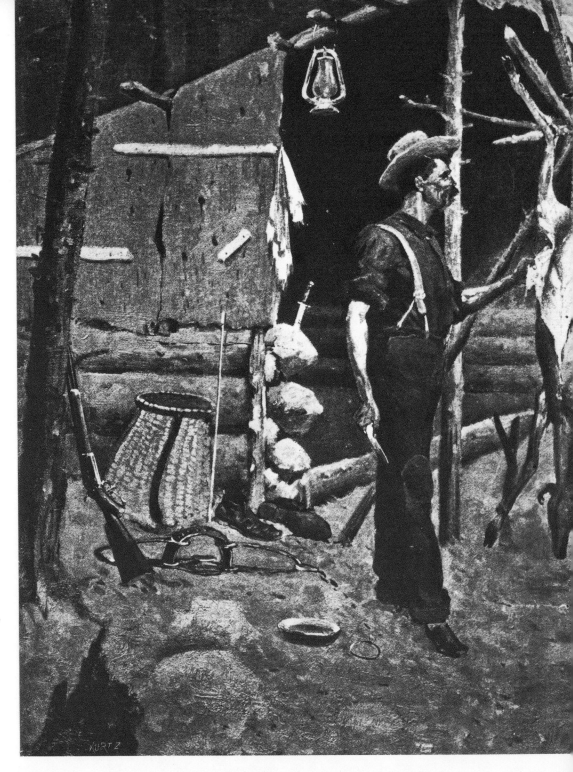

THE HUNTING CAMP—
A GOOD DAY'S HUNTING
IN THE ADIRONDACKS

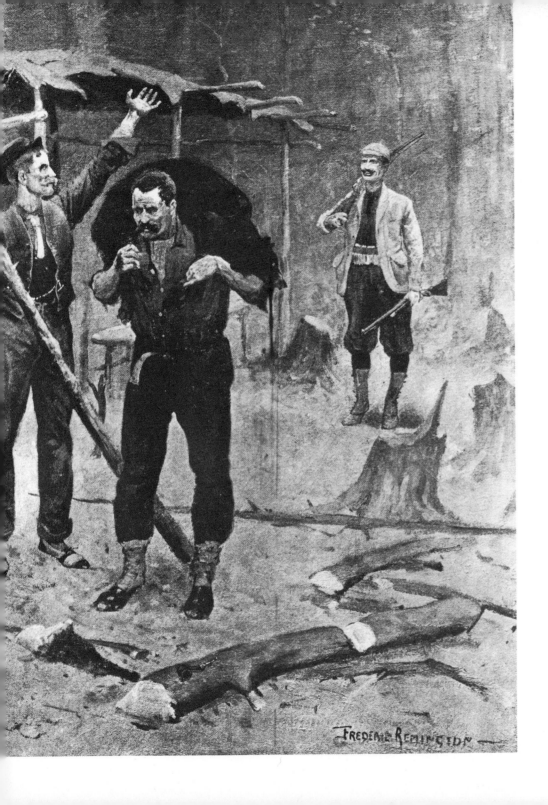

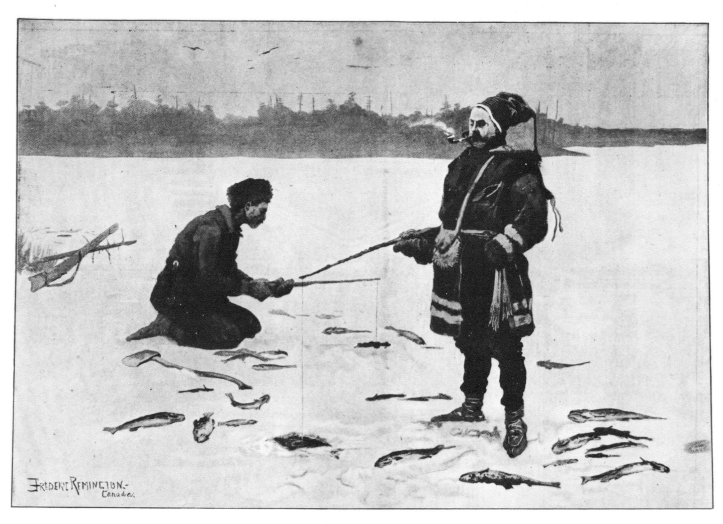

TROUT-FISHING THROUGH THE ICE IN THE CANADIAN WILDERNESS

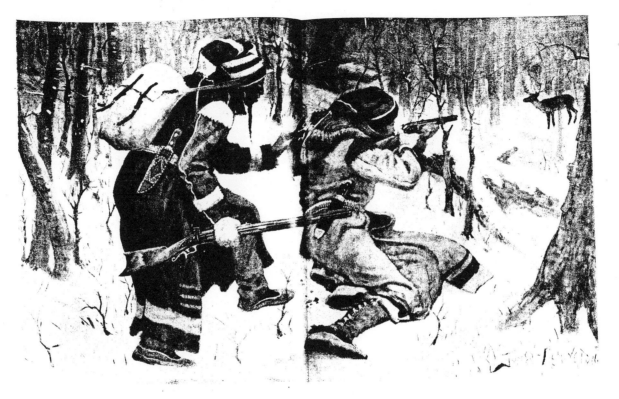

HUNTING THE CARIBOU—"SHOOT! SHOOT!"

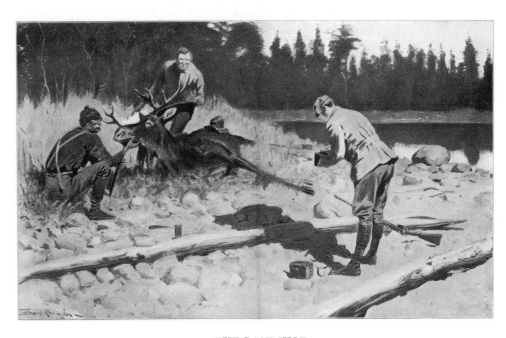

THE LAST SHOT

# People

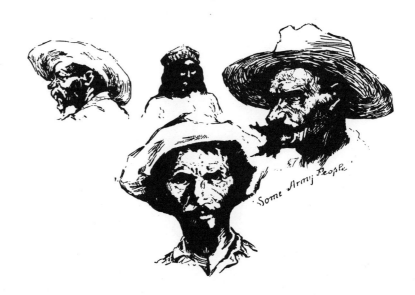

Some Army People

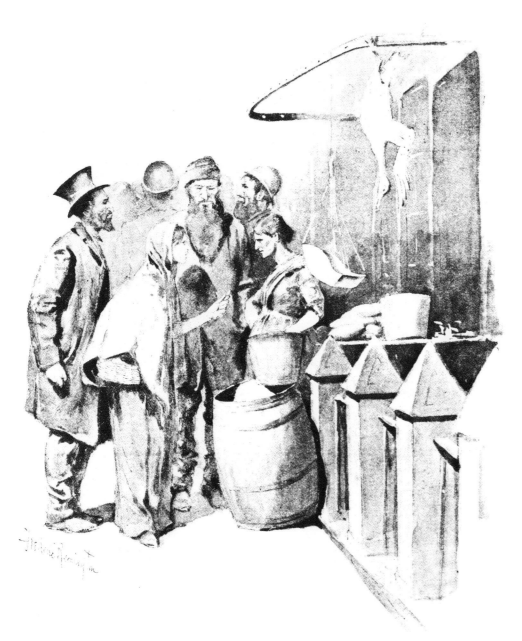

THE SIDEWALK MARKET, LUDLOW STREET

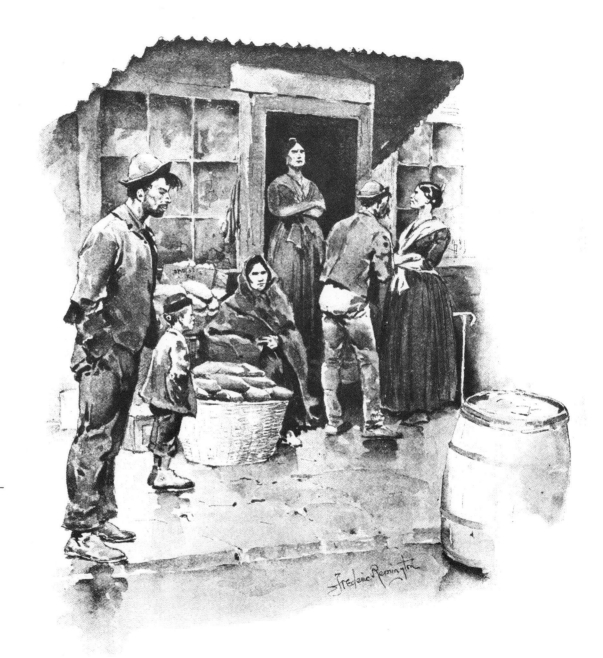

A SKETCH IN MULBERRY BEND—
THE ITALIAN QUARTER

THE LONGSHOREMAN—"NO WORK
AND NO MONEY AND NO HOME "

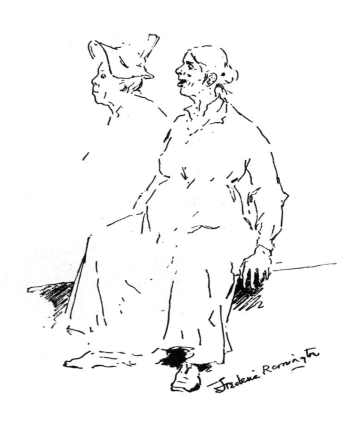

A HAPPY FEMALE LODGER

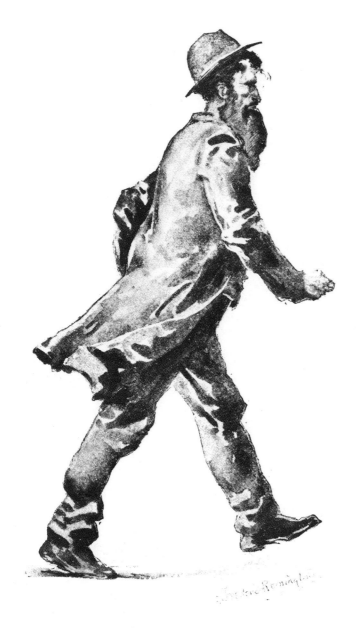

A RUSSIAN JEW

AN EAST-SIDE POLITICIAN

65

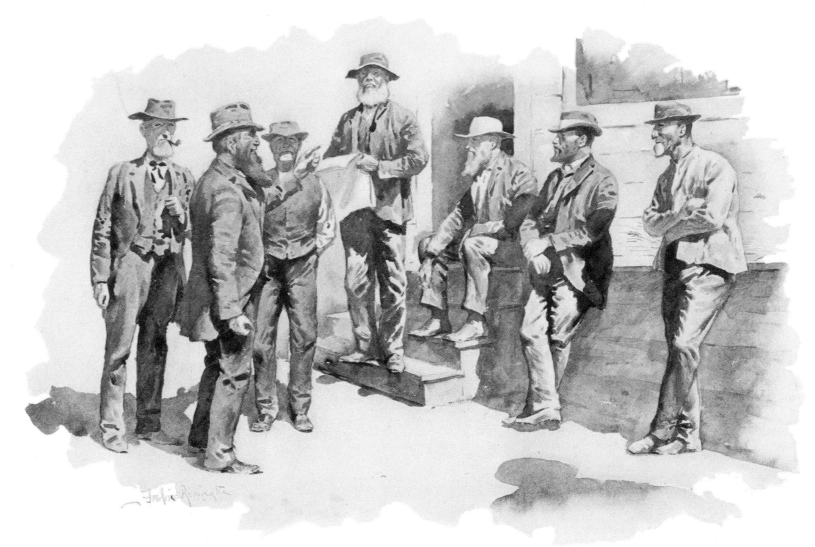

HIGH FINANCE AT THE CROSS-ROADS

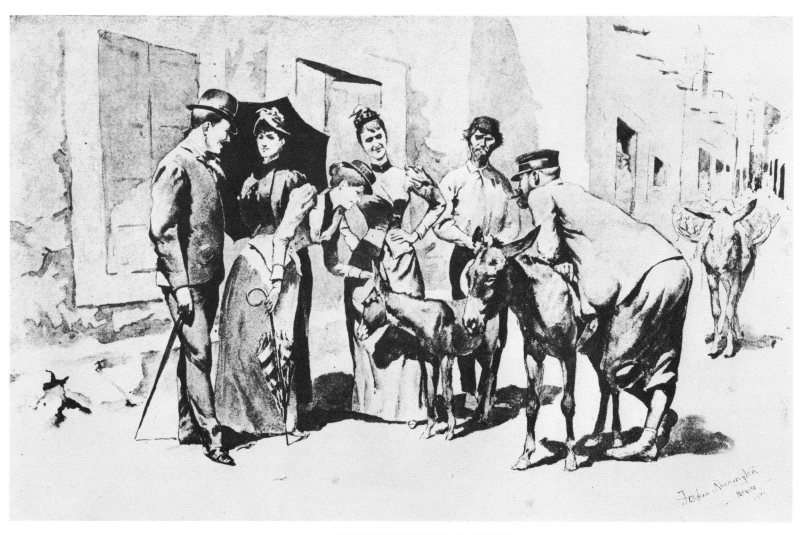

AMERICAN TOURISTS IN MEXICO

AN UNEXPECTED PLEASURE                    AN AMERICAN FREEDOM OF CARRIAGE

A FREIGHT CAR

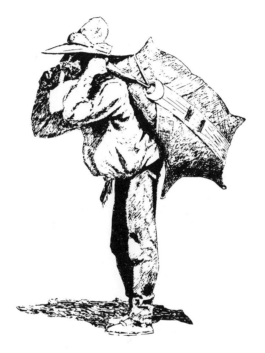

THE PULQUE MAN

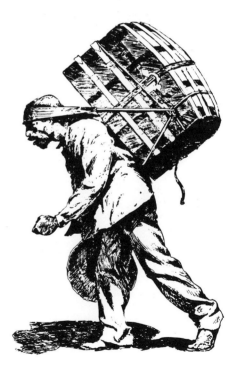

A BAGGAGE WAGON

69

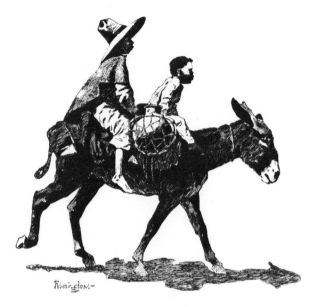

A FAMILY AFFAIR

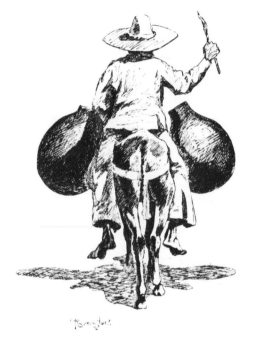

A POINT OF VIEW

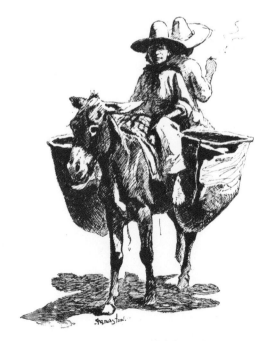

AN EQUINE FREIGHT CAR

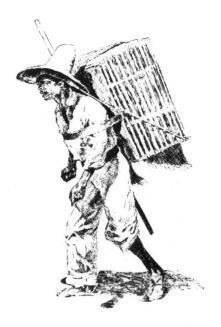

CHICKEN-SELLER

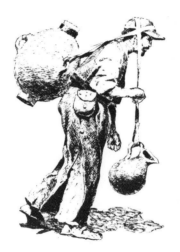

WATER-CARRIER

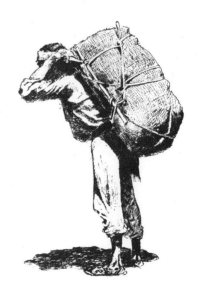

PORTER

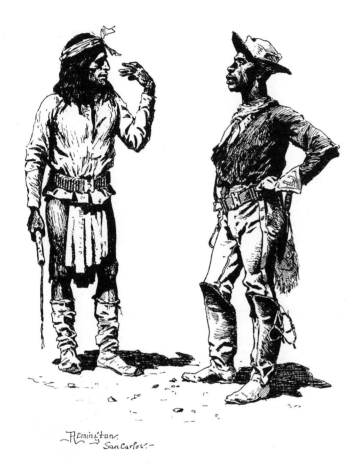

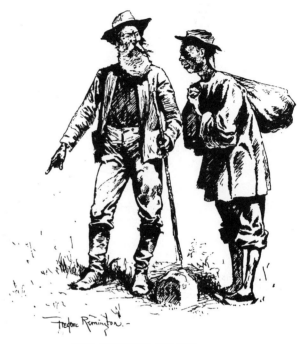

THE CHINESE PILOT:
"THAT IS THE UNITED STATES"

THE SIGN LANGUAGE

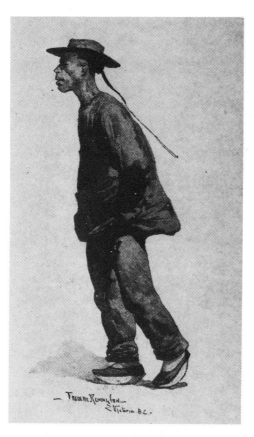

"JOHN"

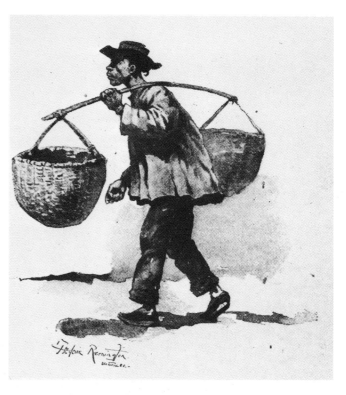

SKETCH OF CHINESE WITH BASKETS

73

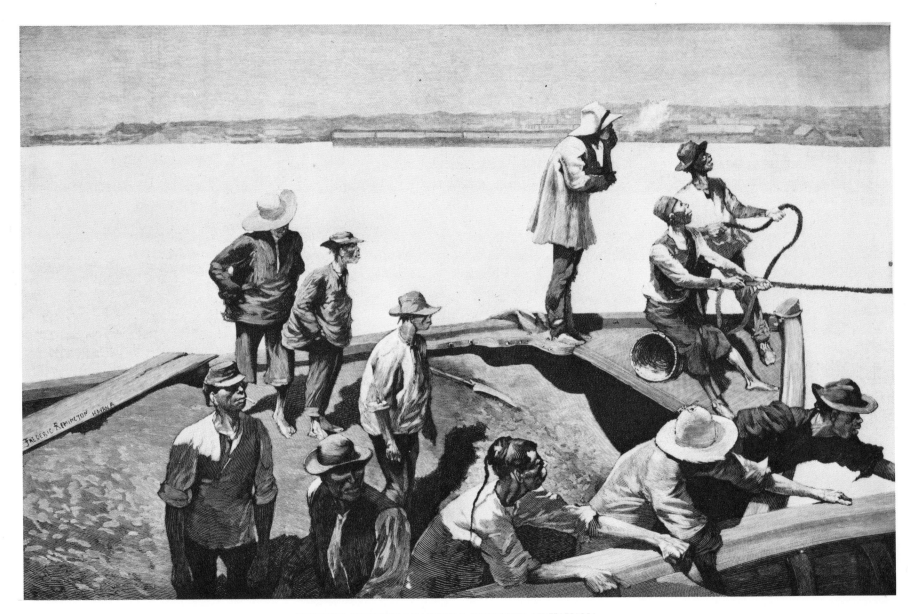

CHINESE COOLIES LOADING A STEAMER AT HAVANA

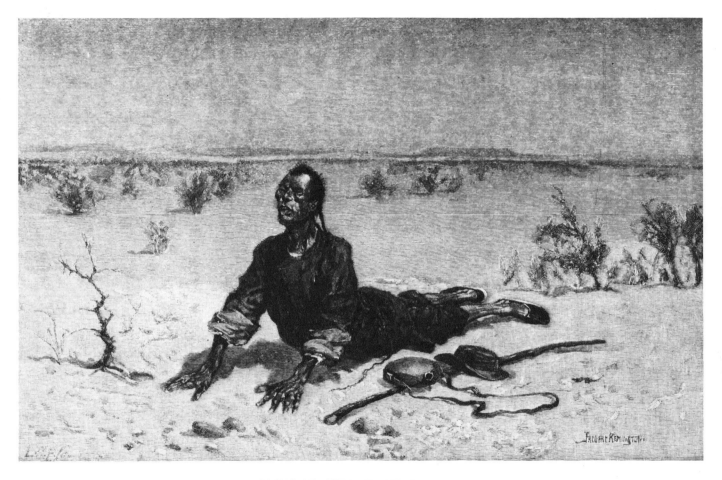

DYING OF THIRST IN THE DESERT

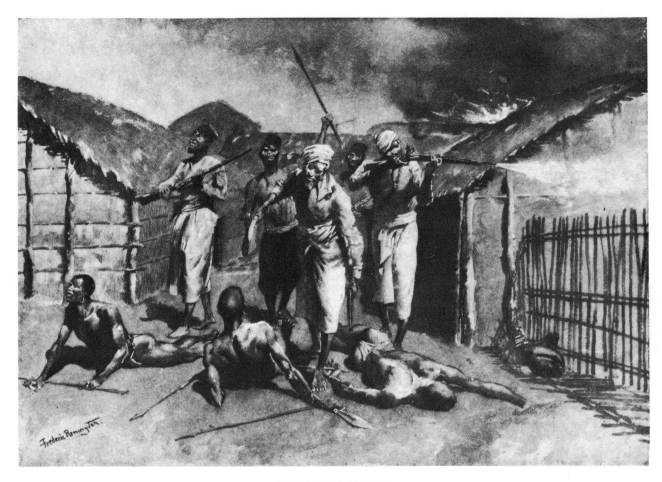

CAPTURING SLAVES

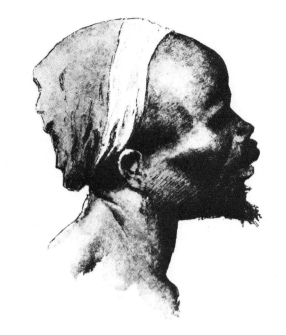

AN ARAB

A SLAVER

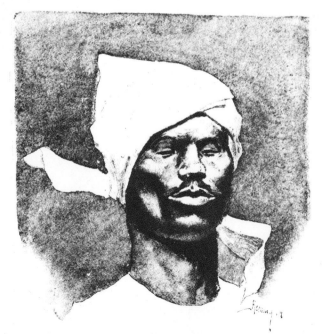

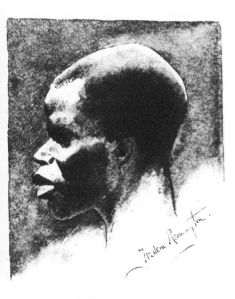

BOY SLAVE

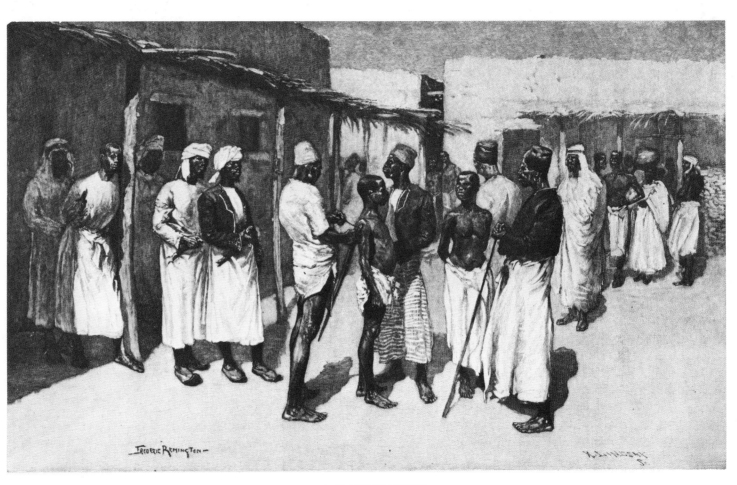

A SLAVE MARKET

EXPLAINING DEFEAT TO THE OWNERS

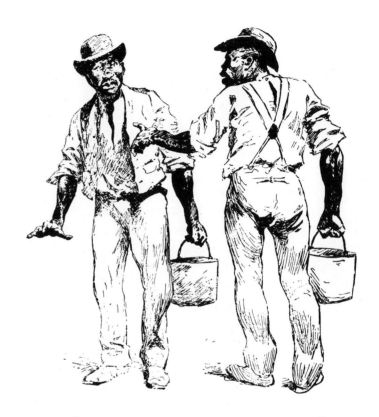

"YOU SUAH LOSE DAT TWO DOLLARS, JIM"

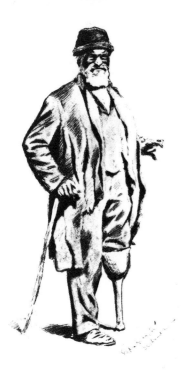

A RELIC

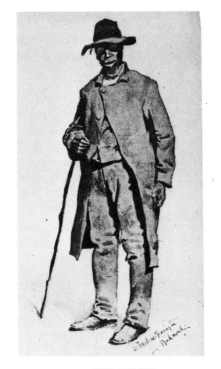

AN OLD-TIMER

THIS TYPE EXISTS

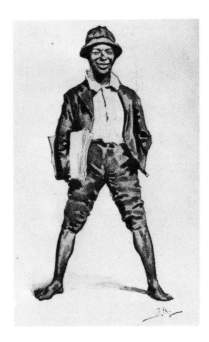

THE NEW IDEA IN MAHOGANY

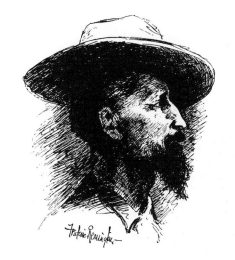

HON. C. J. JONES, GARDEN CITY, KANSAS

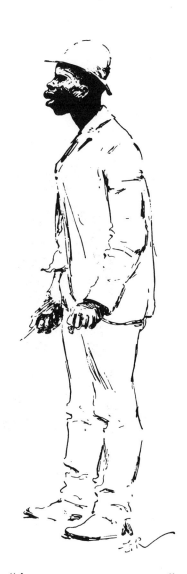

"I'LL CUT YER HEART OUT"

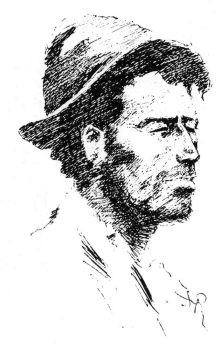

FROM SUNNY ITALY
TO MULBERRY BEND

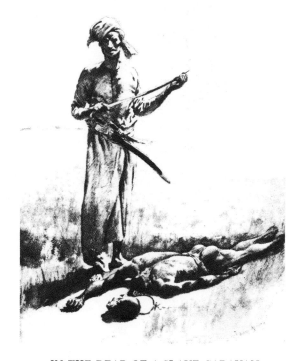

IN THE REAR OF A SLAVE CARAVAN

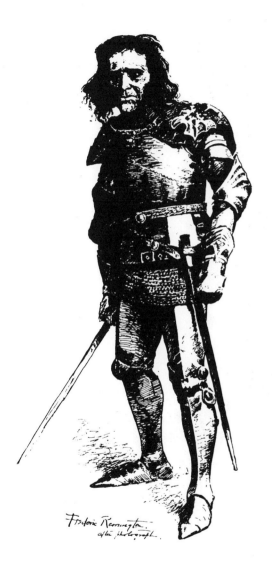

RICHARD MANSFIELD AS RICHARD THE THIRD

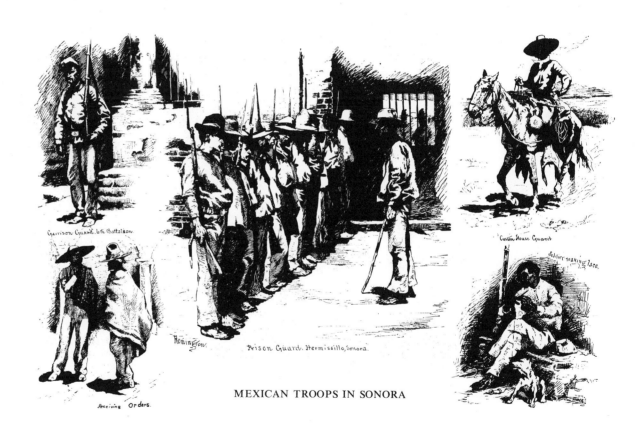

MEXICAN TROOPS IN SONORA

81

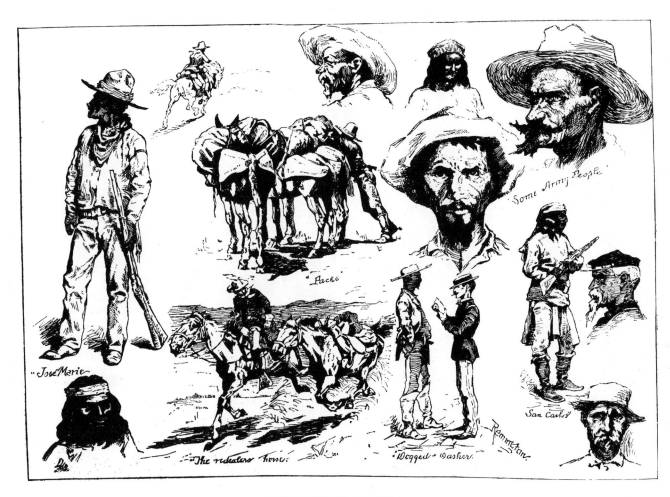

TYPES FROM ARIZONA

# Bull Fighting

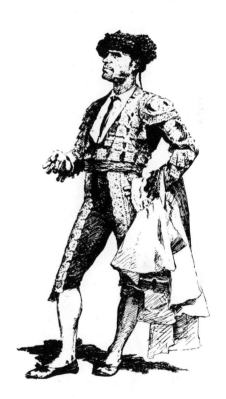

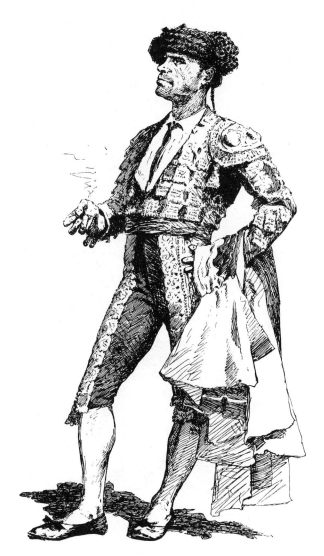

EL CAPITAN

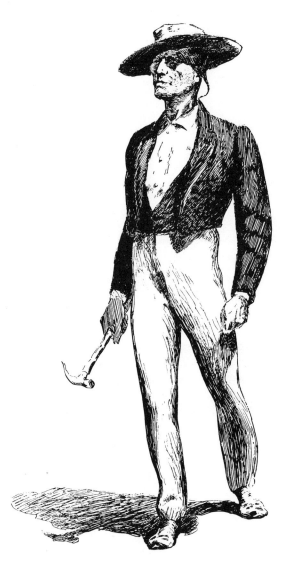

EL CAPITAN IN STREET COSTUME

EL CAPEADOR—THE BANDERILLERO'S PLAY

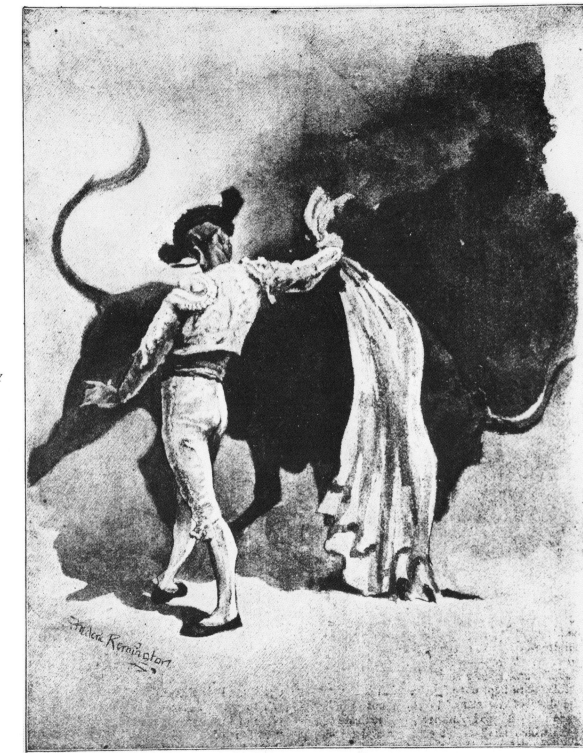

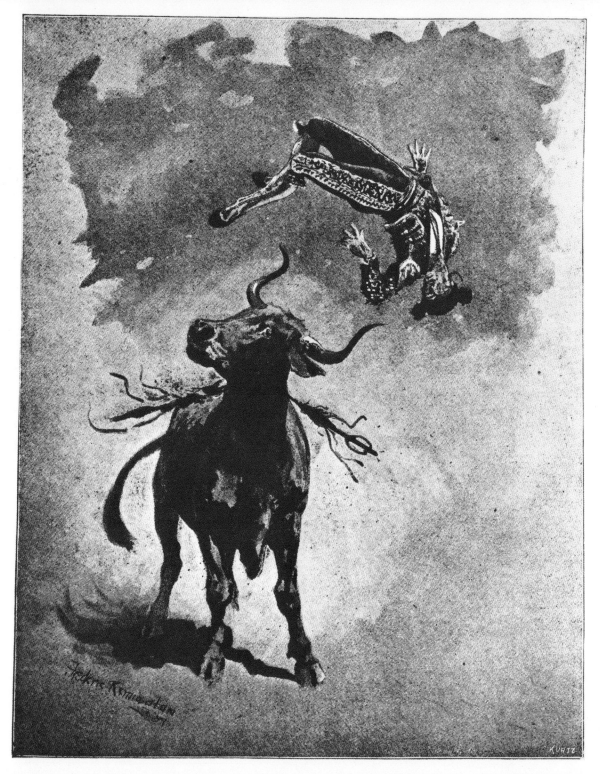

A CHULILLO IN TROUBLE

EL PICADOR

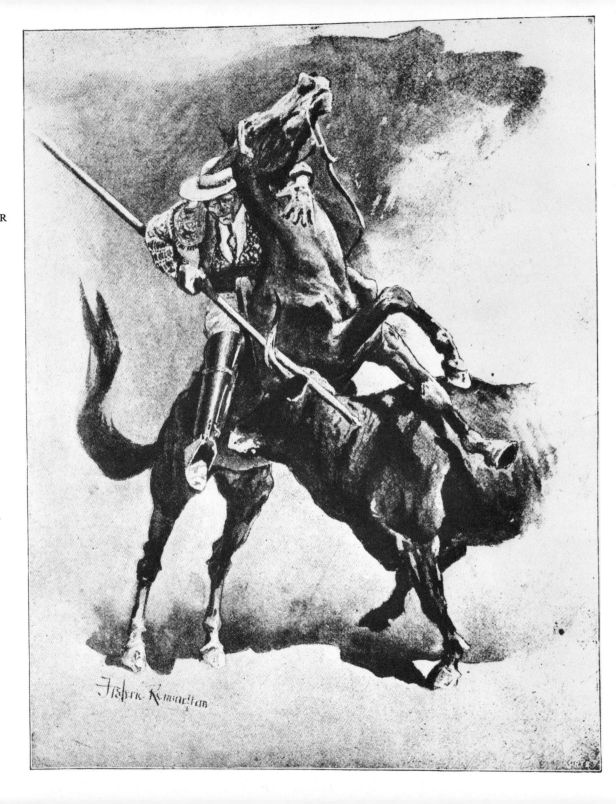

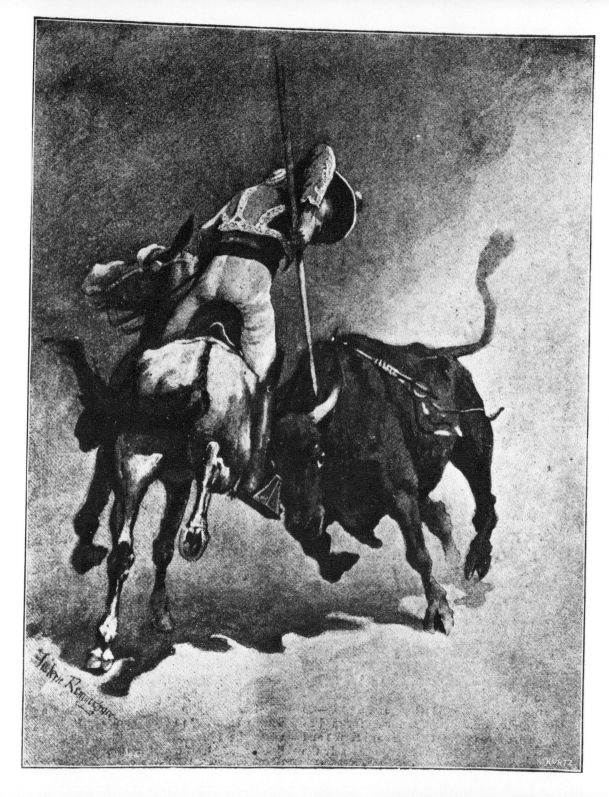

THE PICADOR RECEIVING
A CHARGE OF THE BULL

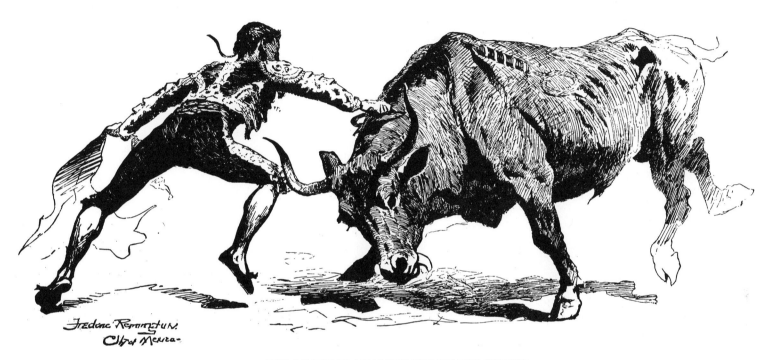

THE MATADOR DEALING THE DEATH STROKE

# Architectural Studies and Landscapes

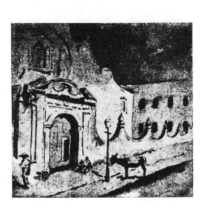

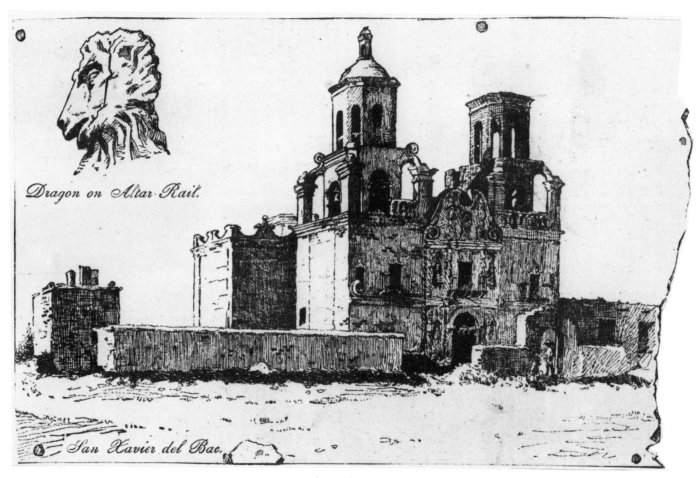

Dragon on Altar Rail.

San Xavier del Bac.

SAN XAVIER DEL BAC (*inset*) DRAGON ON ALTAR RAIL

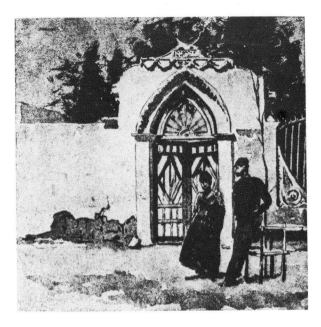

GARDEN GATE, AGUAS CALIENTES

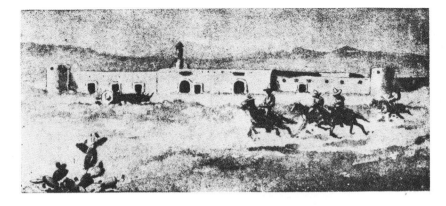

A HACIENDA

STAKE AND MUD HUT

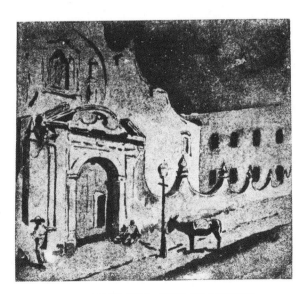

CHURCH FRONT, CITY OF MEXICO

IN PIEDRAS NEGRAS

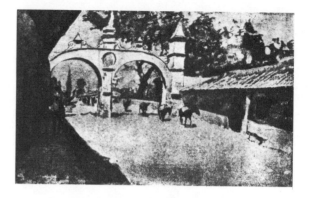

GATEWAY TO ORIZABA

POOR QUARTER, CITY OF MEXICO

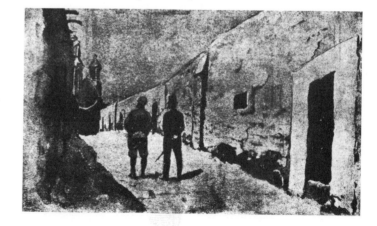

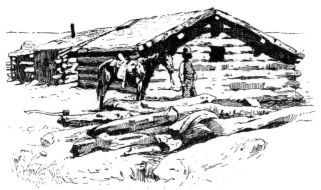

RANCH HOUSE—BOW RIVER

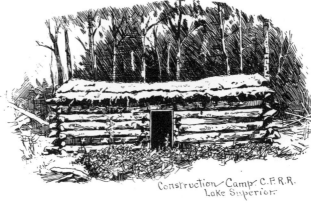

CONSTRUCTION CAMP C. P. R. R. LAKE SUPERIOR

LOG AND BOARD HOUSE — ONTARIO

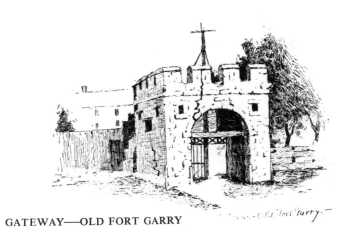

GATEWAY—OLD FORT GARRY

BARRACKS AT CALGARY

*Frederic Remington*

SKETCH FROM THE SHORE OF LAKE SUPERIOR

CAMP OF INSTRUCTION

OLD INDIAN TRADING POST—ELBOW RIVER

A MANITOBA FARM

A GENERAL STORE

MOUNTED POLICE BARRACKS—PINCHER CREEK

WASHINGTON'S HEADQUARTERS

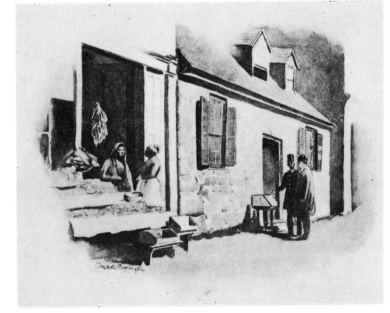

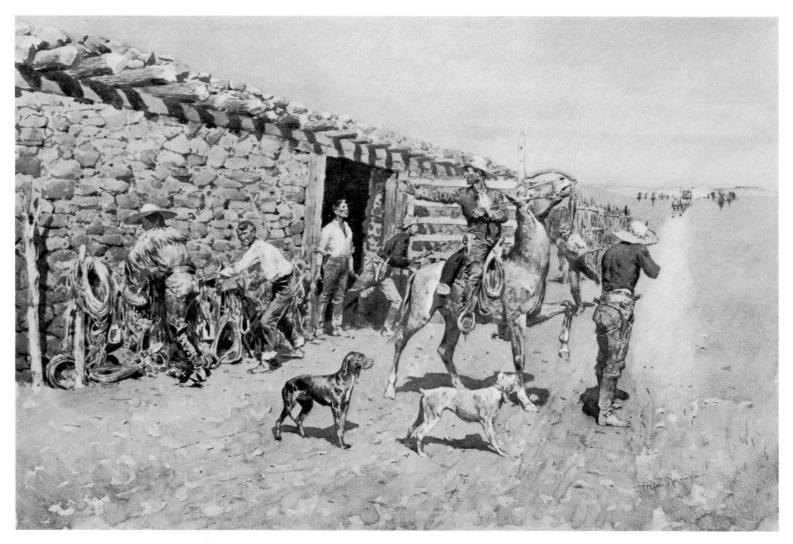

AN OVERLAND STATION: INDIANS COMING IN WITH THE STAGE

# Animals in the Wilds

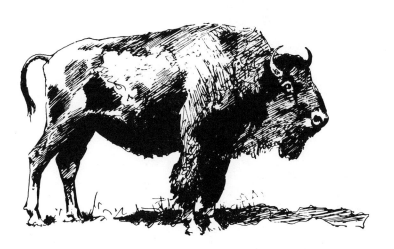

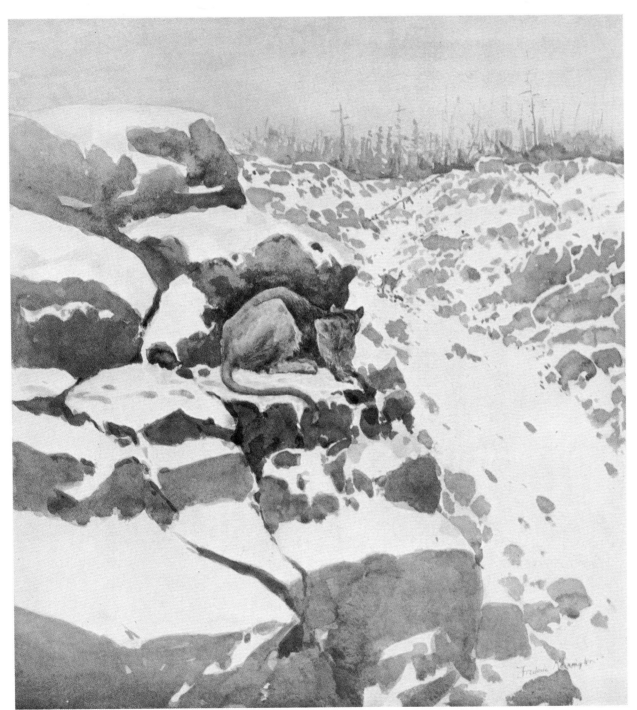

A MOUNTAIN LION HUNTING

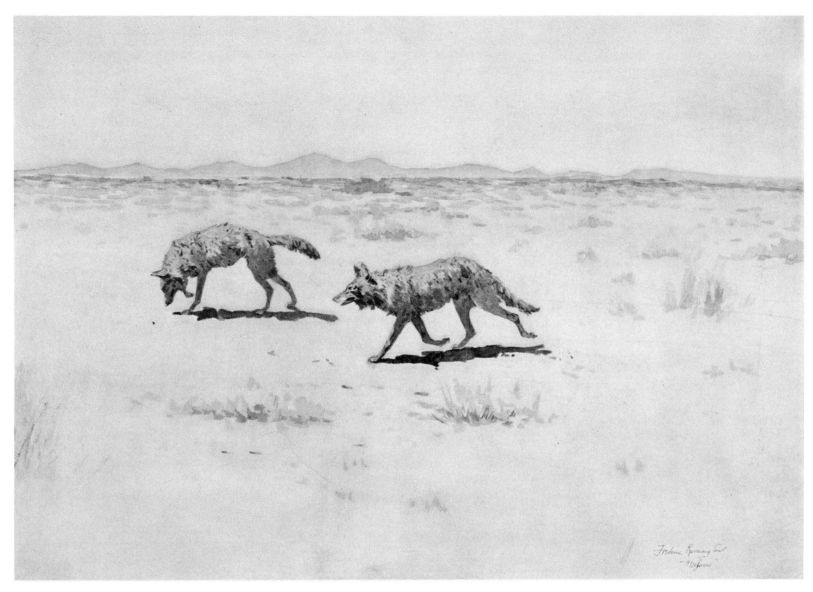

COYOTES

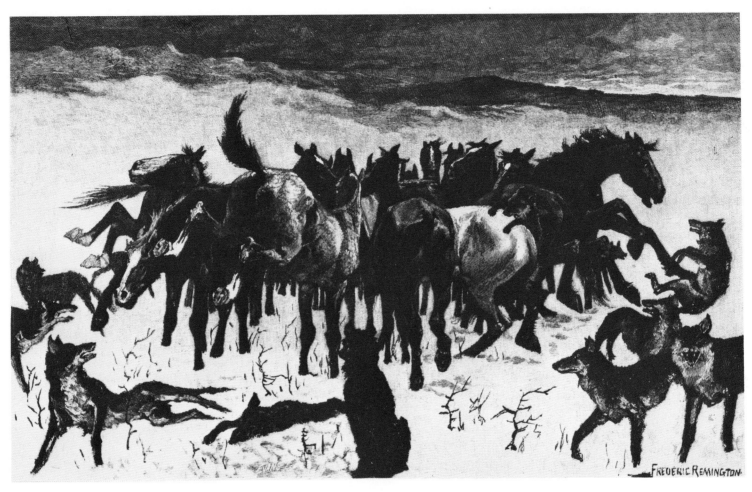

BRONCOS AND TIMBER WOLVES

SIX-YEAR-OLD BULL

COW CAUGHT BY MR. JONES WHEN TIED TO HORSE

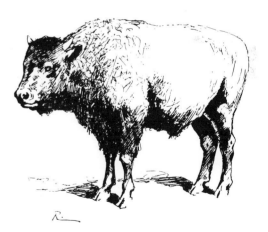

CALF, THREE-FOURTHS BUFFALO

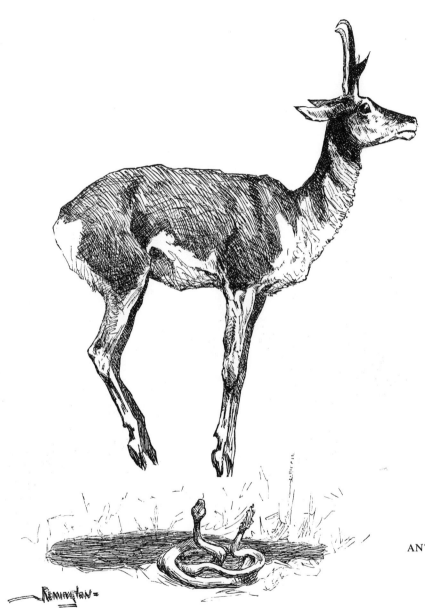

ANTELOPE KILLING A "RATTLER"

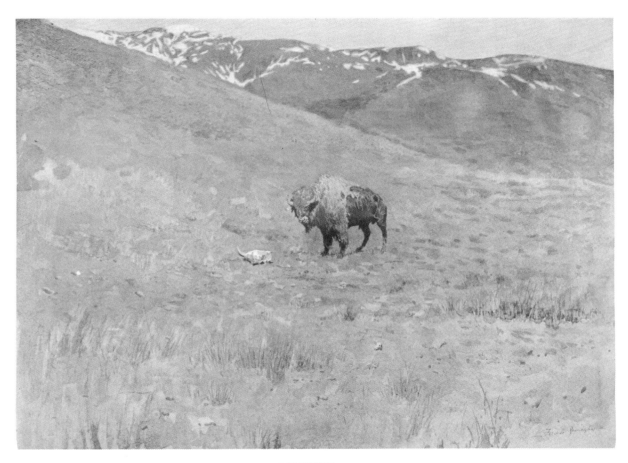

SOLITUDE

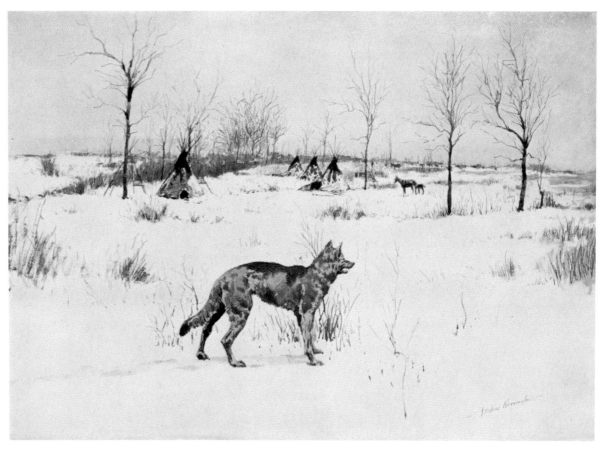

THE HUNGRY WINTER

# Cavalry

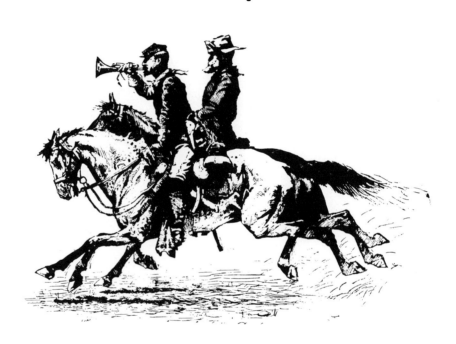

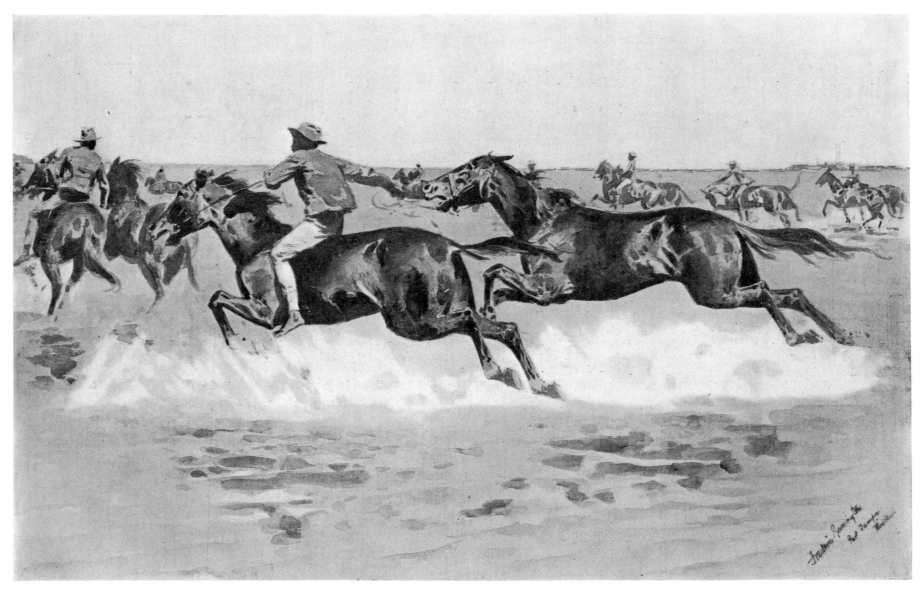

WITH THE REGULARS AT PORT TAMPA, FLORIDA—COLORED TROOPERS
OF THE 9TH U.S. CAVALRY TAKING THEIR HORSES FOR A DASH INTO THE GULF

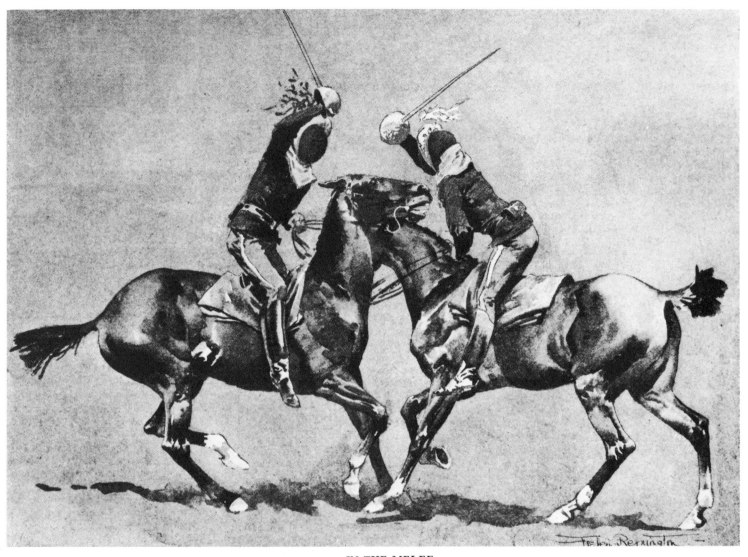

IN THE MELEE

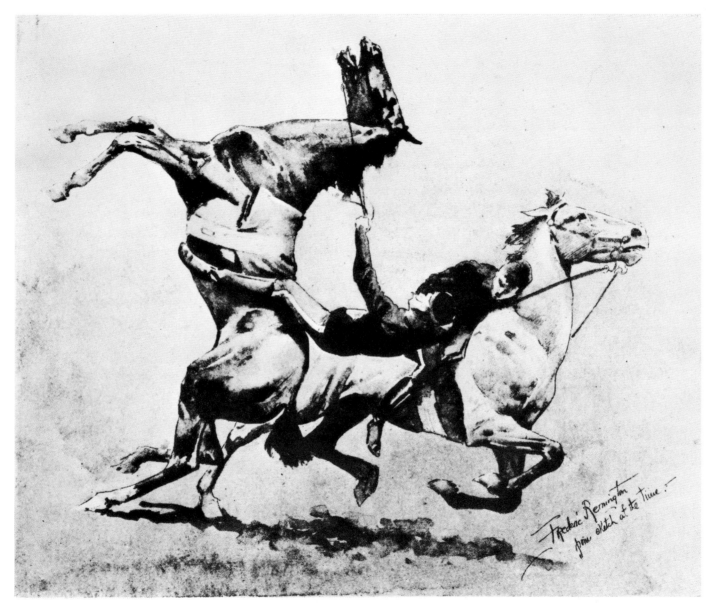

AN INCIDENT OF THE WRESTLING CONTESTS

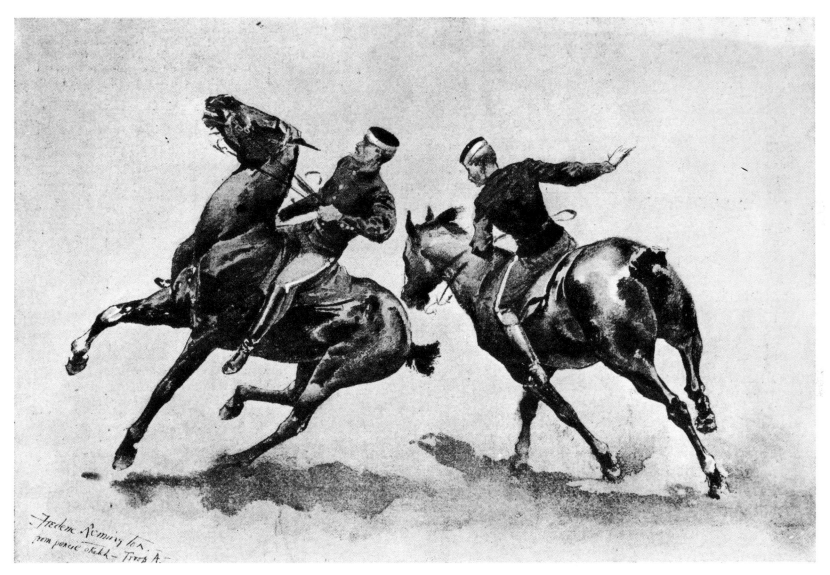

CHASING THE RIBBON——A SHARP TURN

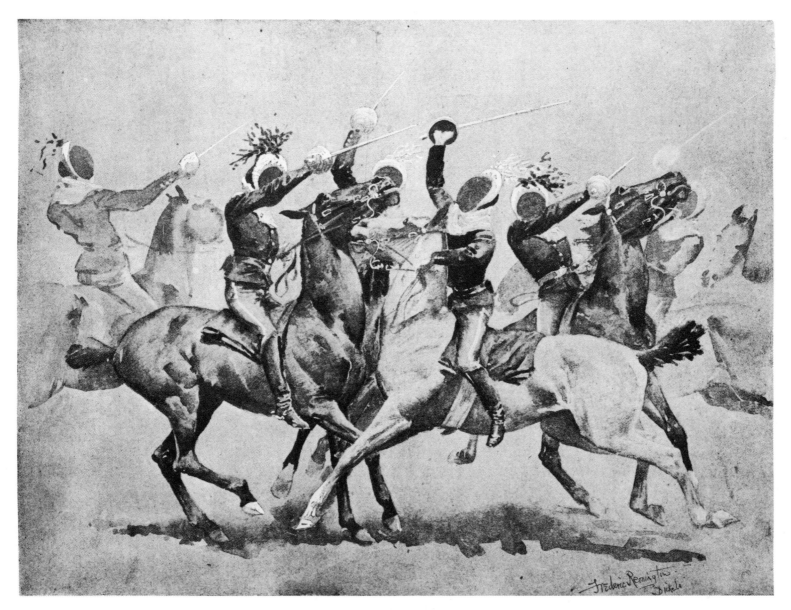

THE MELEE

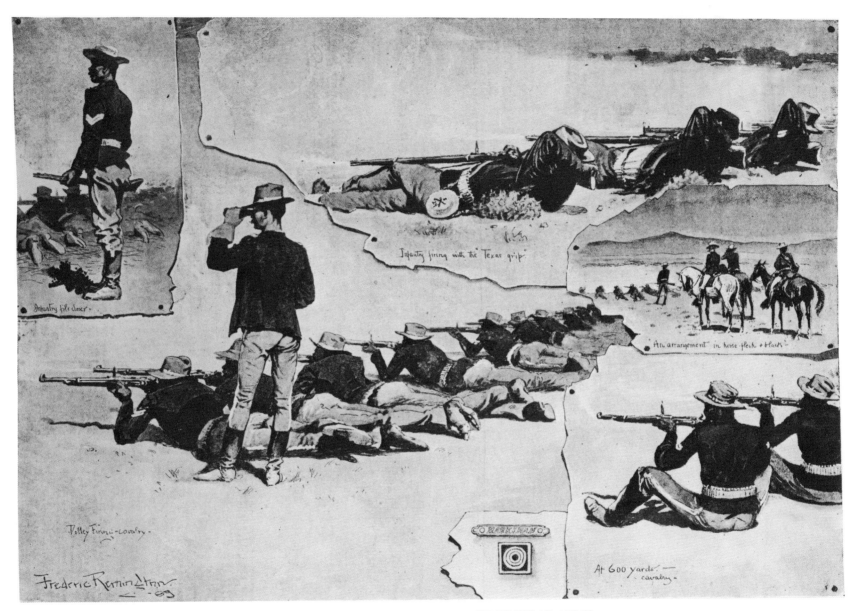

Infantry firing with the "Texas grip"

An arrangement in horse flesh & black

Infantry file closer

Volley Firing—cavalry

MARKSMAN

At 600 yards—
cavalry

Fredric Remington
'89

SKIRMISH LINE TARGET PRACTICE IN THE REGULAR ARMY

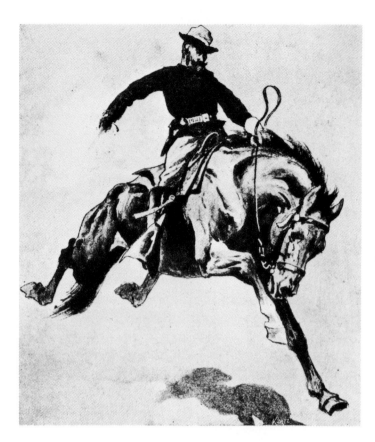

A PLUNGER

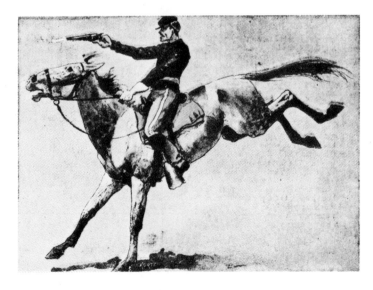

A KICKER

A REARER

114

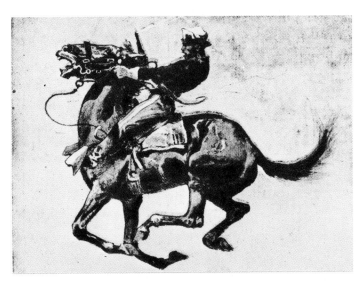

UGLY

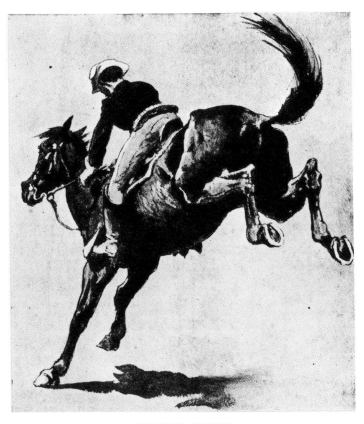

ANOTHER KICKER

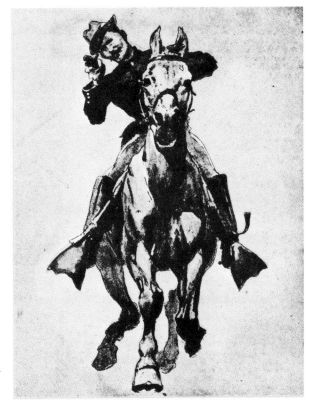

A STEADY GOER

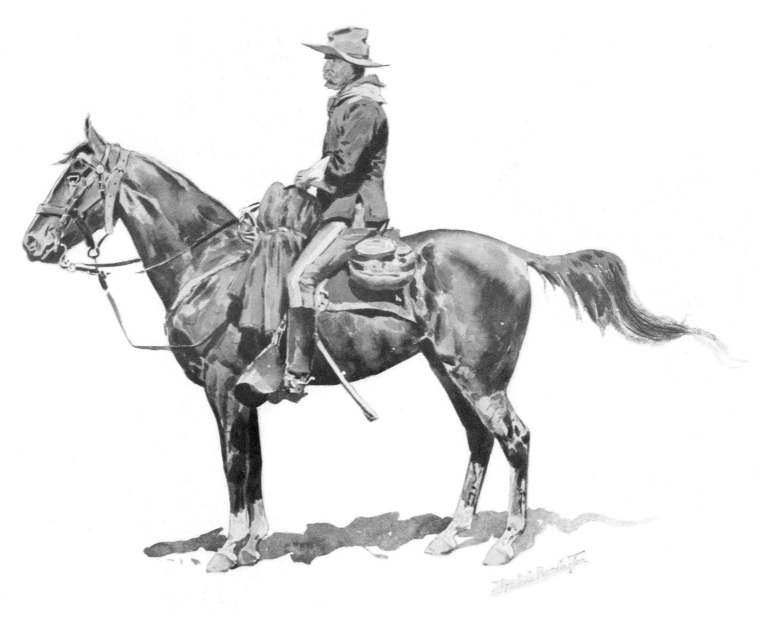

U. S. CAVALRY OFFICER ON CAMPAIGN

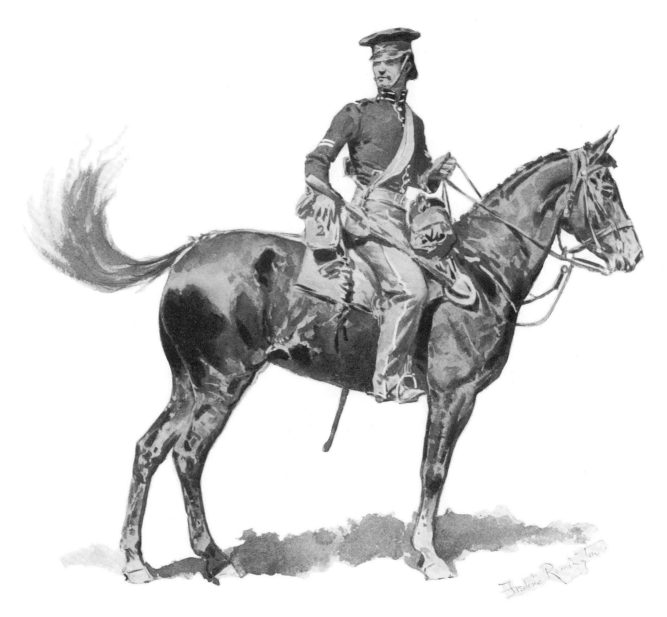

U. S. DRAGOON, '47

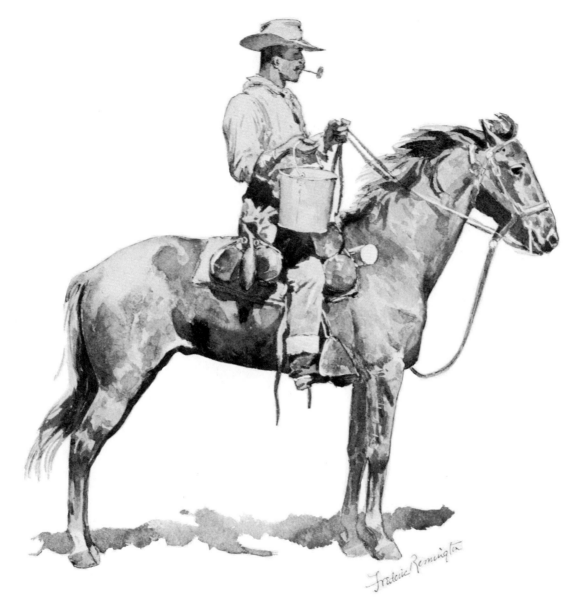

THE CAVALRY COOK WITH WATER

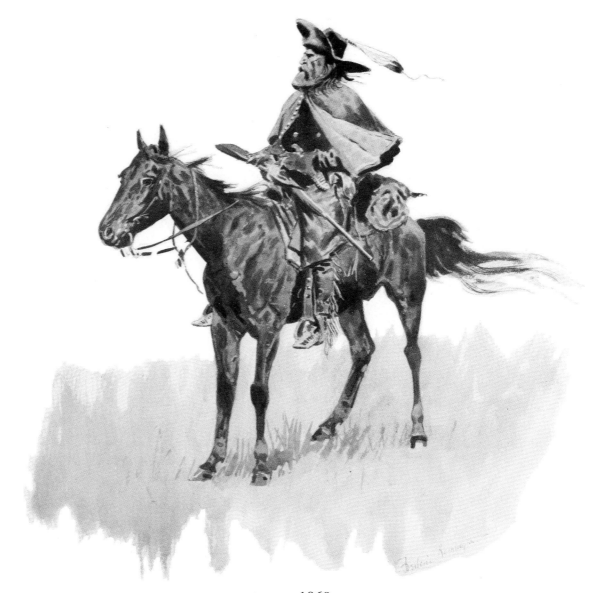

A SCOUT, 1868

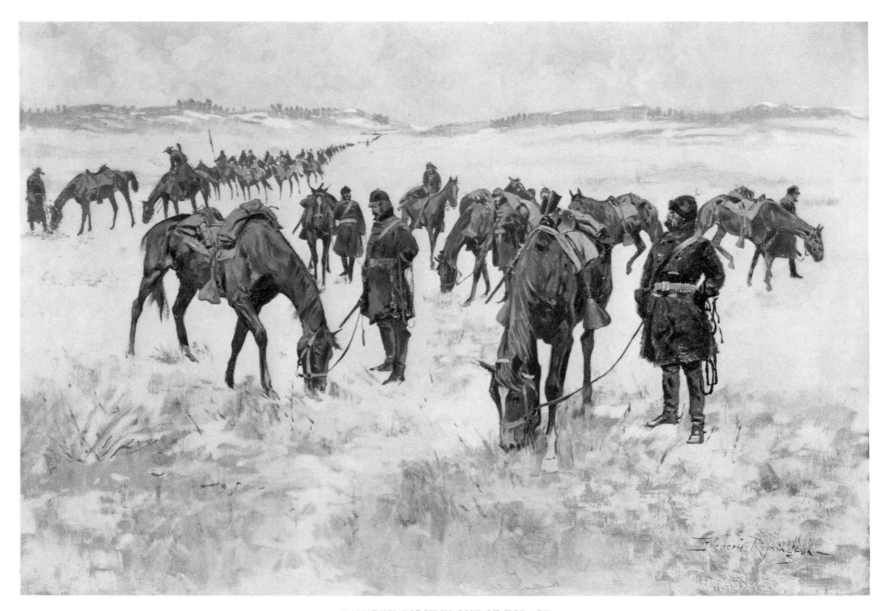

CAVALRY COLUMN OUT OF FORAGE

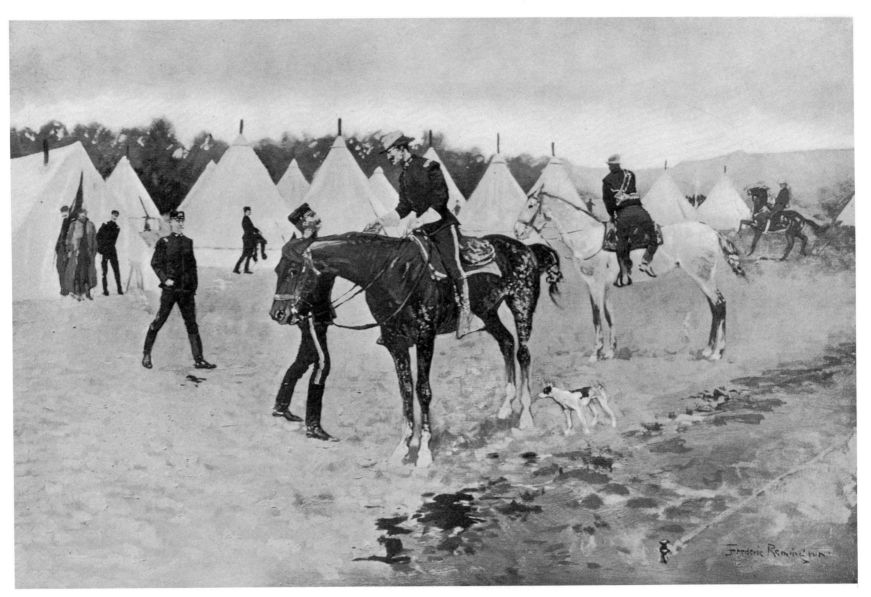

A MODERN CAVALRY CAMP

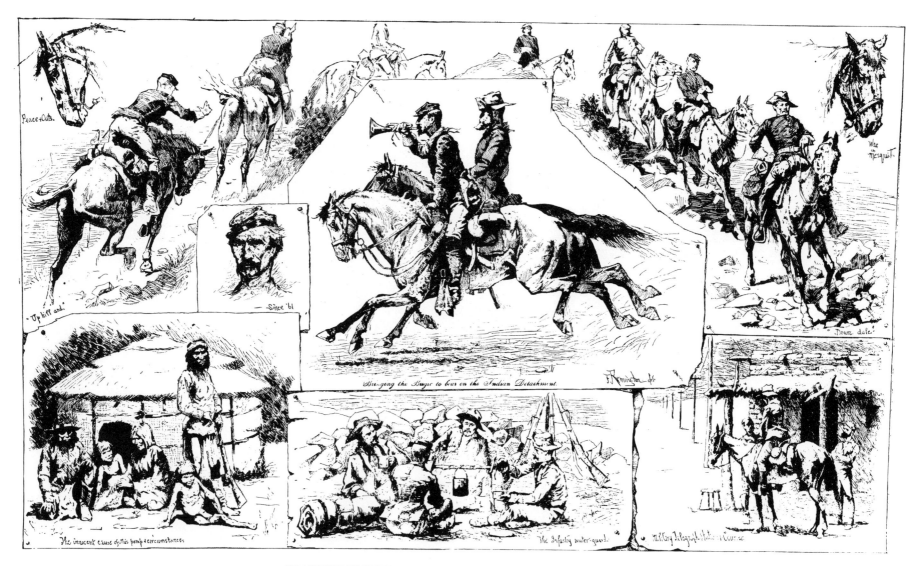

Peace Oats.

Up hill and.

Since '61

Bringing the Bugle to bear on the Indian Detachment.

F. Remington del.

War on Mesquite.

Down dale.

The innocent cause of this pomp & circumstance.

The Infantry water-guard.

M.P.Gry Telegraph Station — Courier

TRAINING UNITED STATES TROOPS IN INDIAN WARFARE

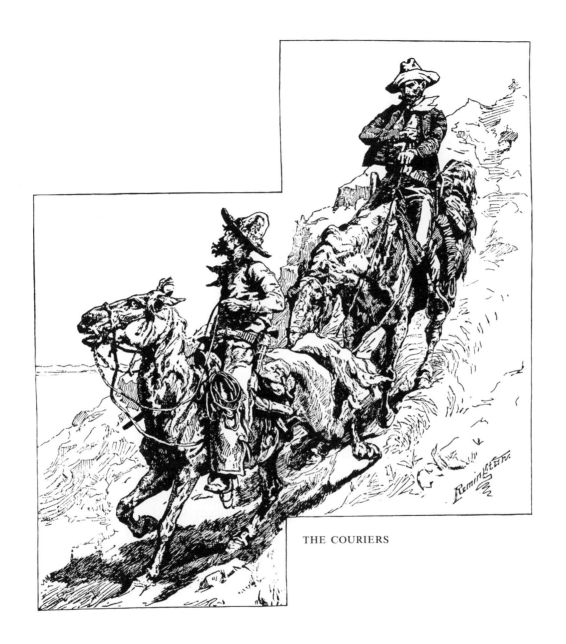

THE COURIERS

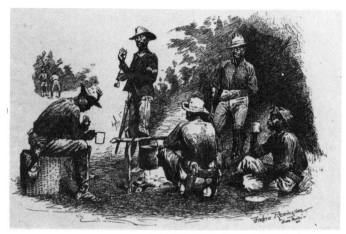

A CAMPFIRE SKETCH

CHASING THE RIBBON

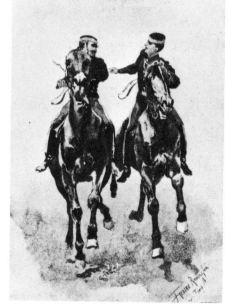

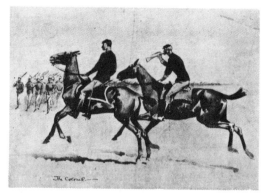

THE COLONEL AND HIS ORDERLY

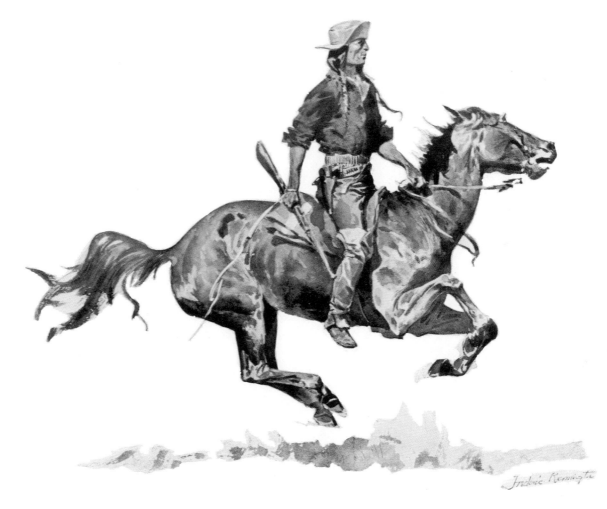

A CROW SCOUT

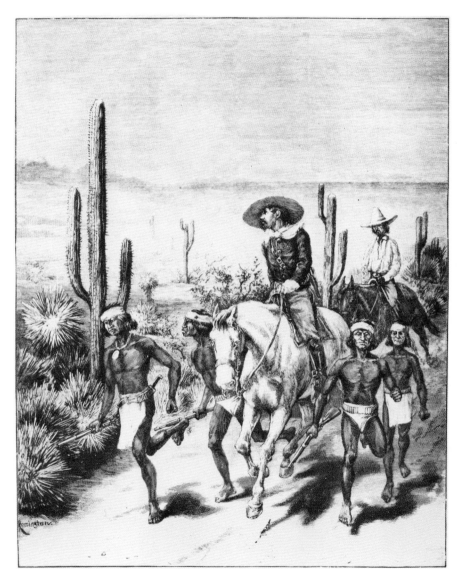

THE APACHE WAR—INDIAN SCOUTS ON GERONIMO'S TRAIL

# Soldiery Artillery

"LOAD!"

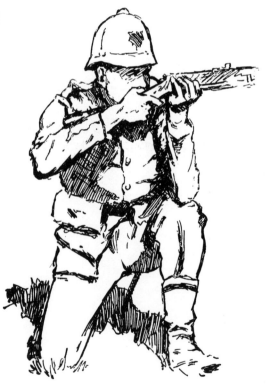

"FIRE KNEELING—AIM!"

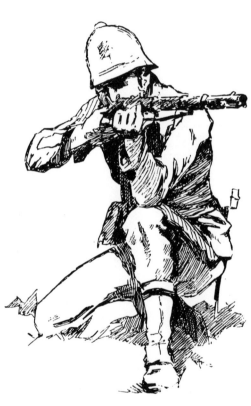

"COMMENCE FIRING!"

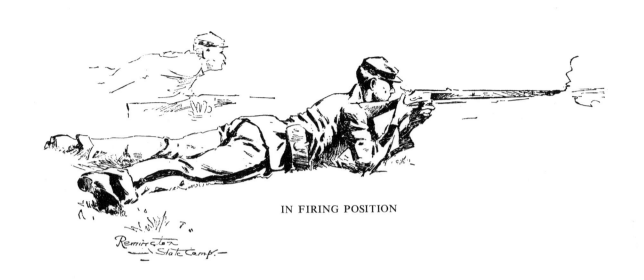

IN FIRING POSITION

THE CALL FOR AMMUNITION

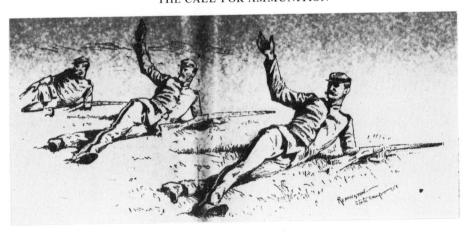

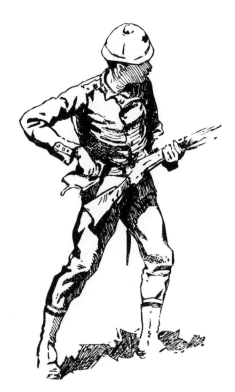

"ADVANCE LOADING!"

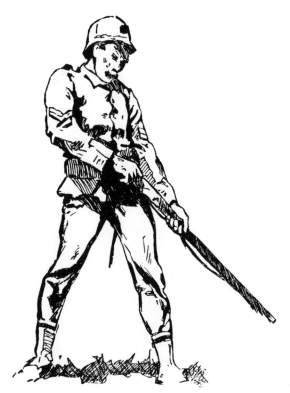

A CARTRIDGE STUCK

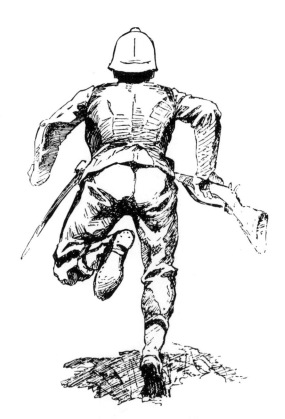

"DOUBLE TIME!"

130

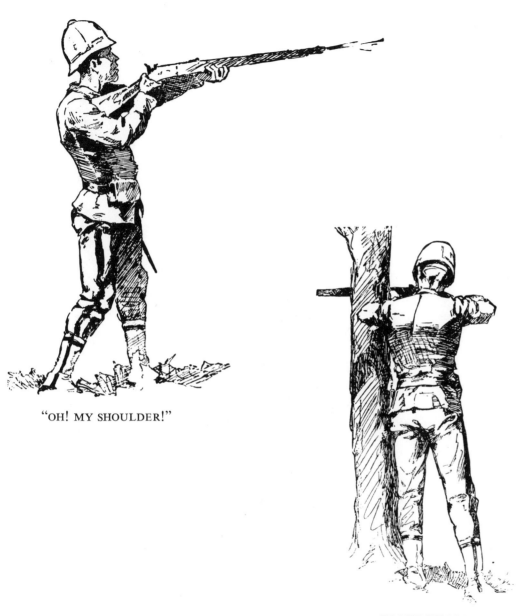

"OH! MY SHOULDER!"

IN THE WOODS

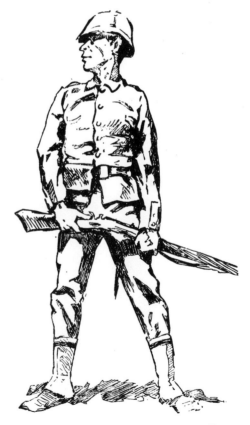

"DON'T UNDERSTAND THE CALL."

131

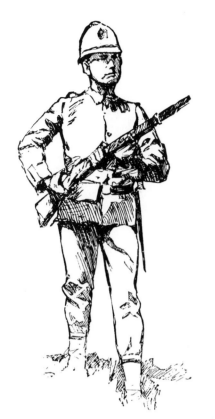

"CEASE FIRING!"

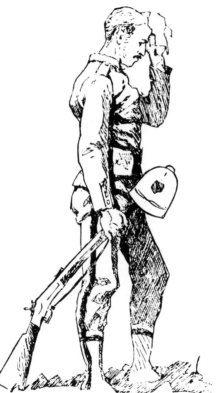

"IN PLACE, REST!"

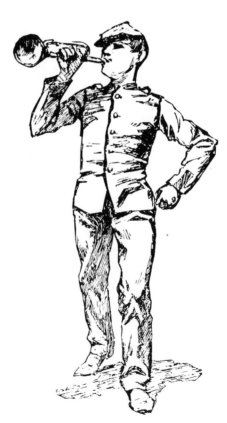

THE BUGLER

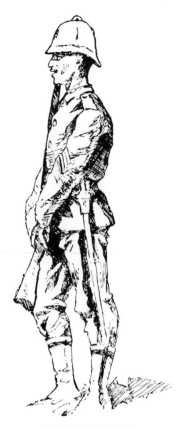

A FILE CLOSER

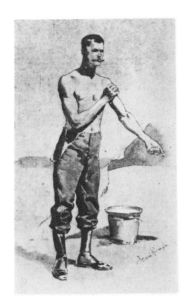

RUB-DOWN

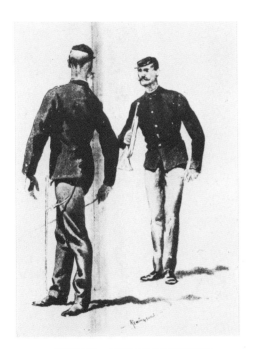

OFFICER AND TRUMPETER

OFF DUTY

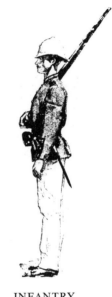

INFANTRY

OFFICER ON SKIRMISH LINE

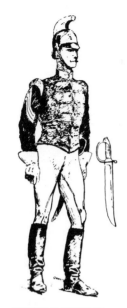

LIGHT BATTERY—
FULL DRESS

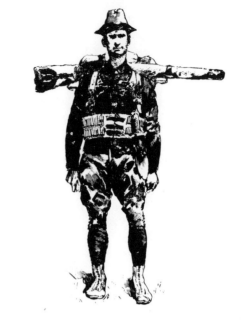

INFANTRY—FIELD OR CAMPAIGN UNIFORM

INFANTRY—
FULL DRESS

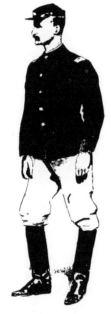

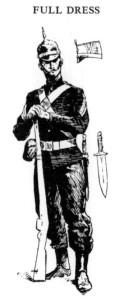

ADJUTANT

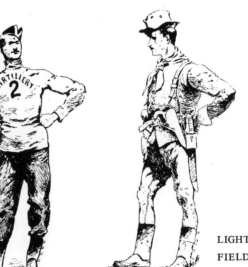

HEAVY ARTILLERY—
FATIGUE DRESS

LIGHT ARTILLERY—
FIELD OR COMPANY UNIFORM

134

STRETCHER DRILL

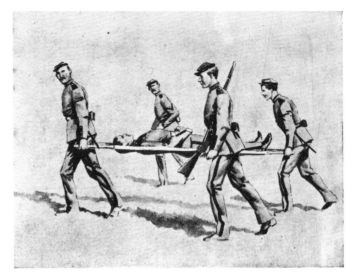

DISMOUNTED SABRE CONTEST

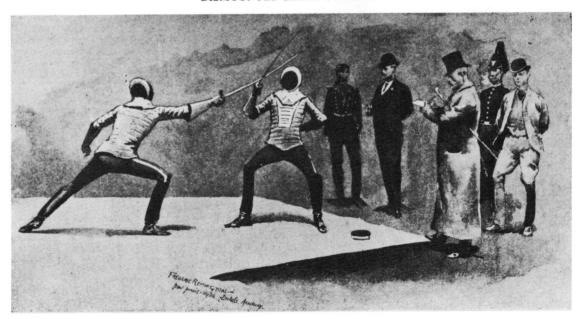

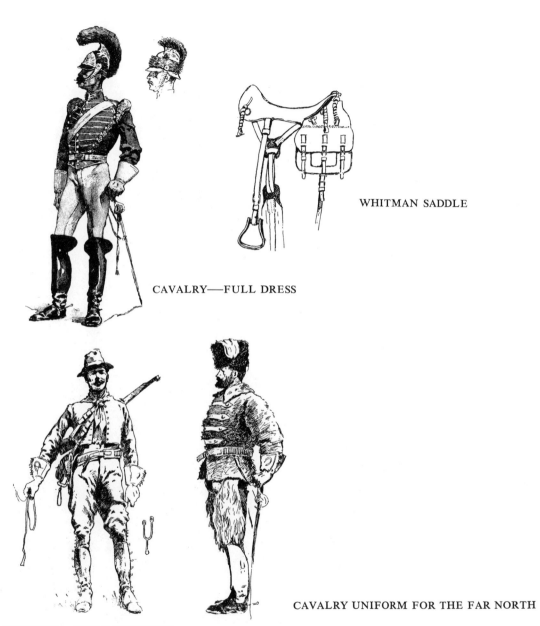

WHITMAN SADDLE

CAVALRY—FULL DRESS

CAVALRY UNIFORM FOR THE FAR NORTH

CAVALRY—FIELD UNIFORM

# Fighting the Indians

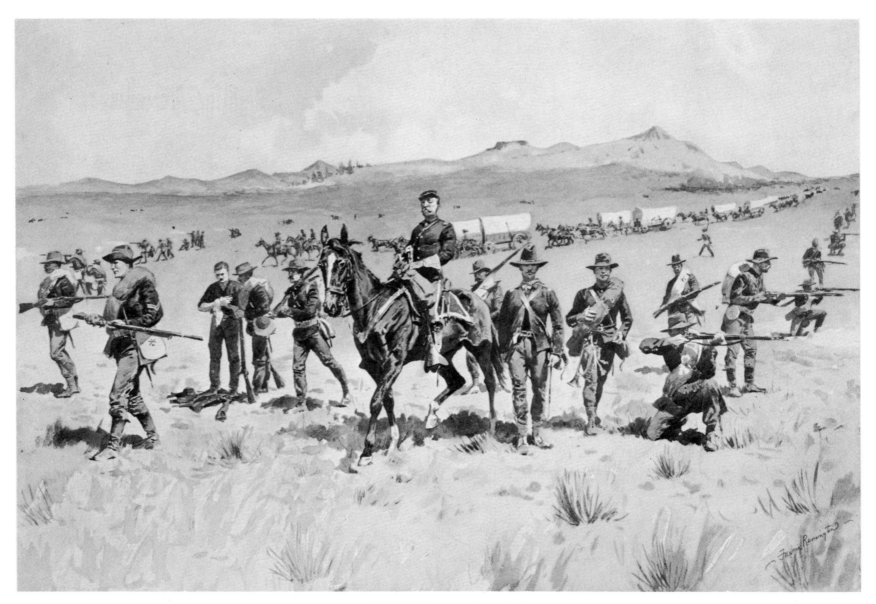

PROTECTING A WAGON TRAIN

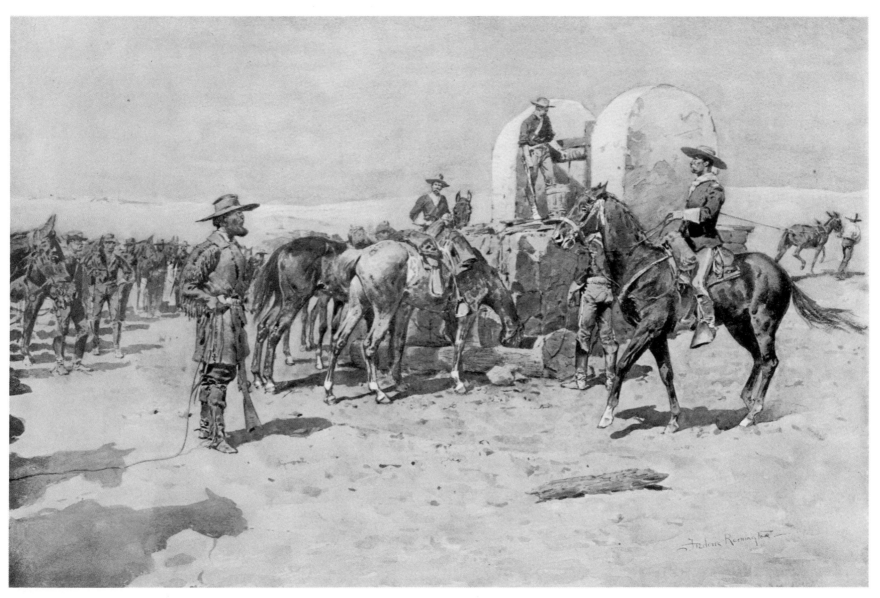

THE WELL IN THE DESERT

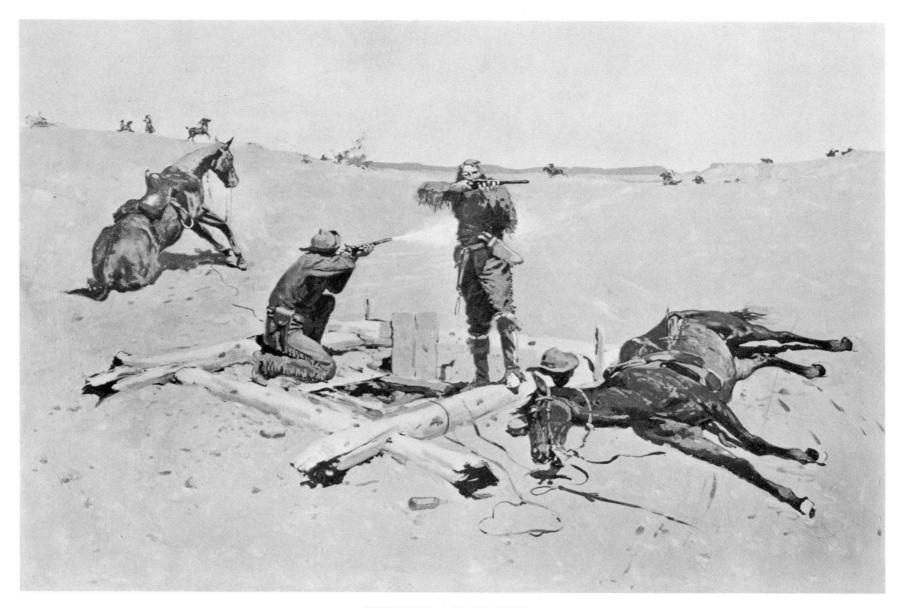

FIGHT OVER A WATER HOLE

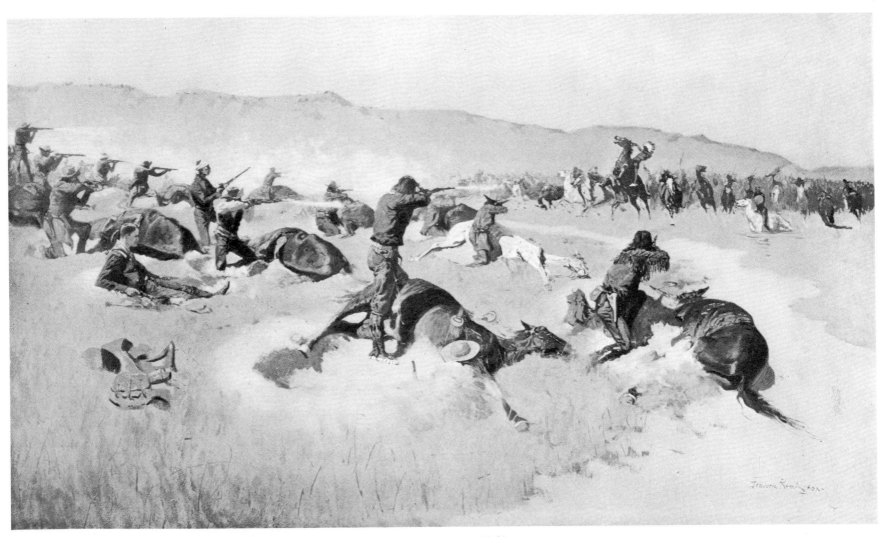

FORSYTHE'S FIGHT ON THE REPUBLICAN RIVER, 1868—THE CHARGE OF ROMAN NOSE

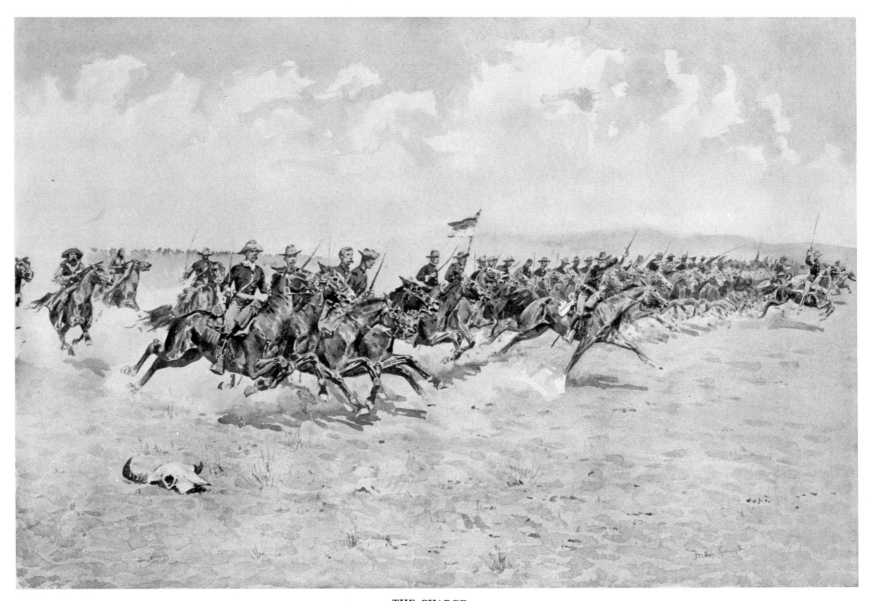

THE CHARGE

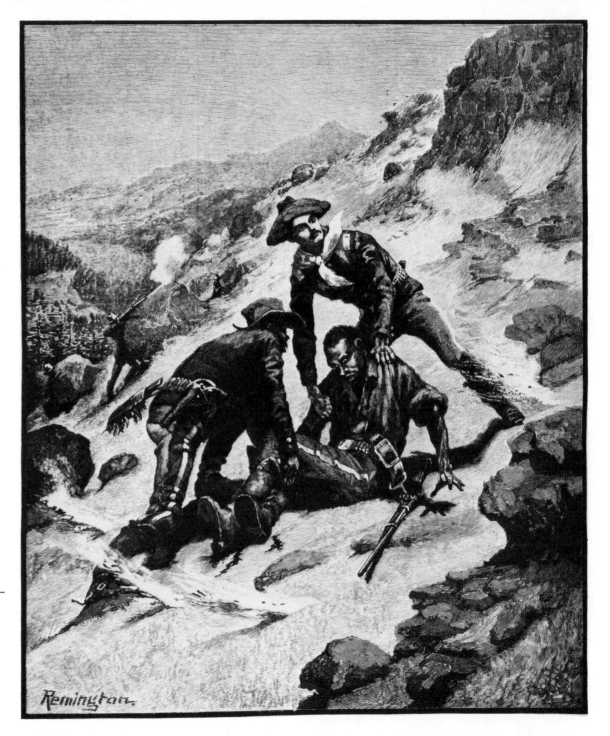

SOLDIERING IN THE SOUTHWEST—
THE RESCUE OF CORPORAL SCOTT

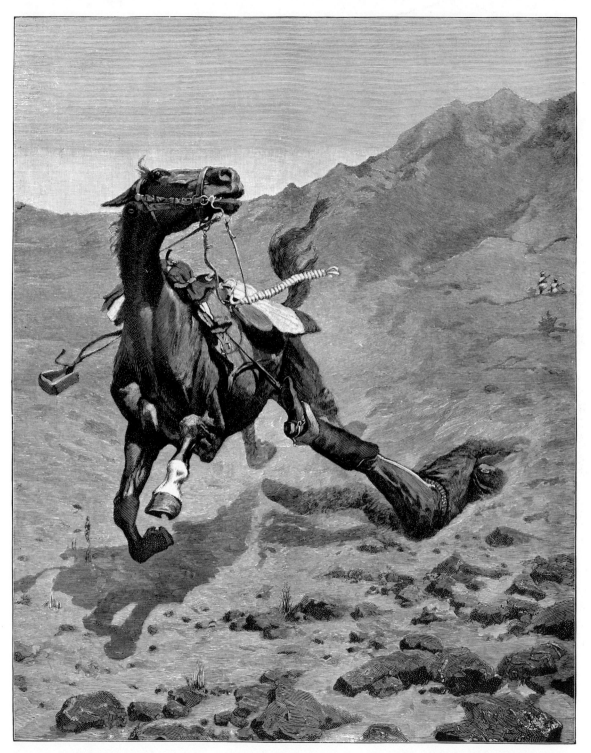

THE AMBUSHED PICKET

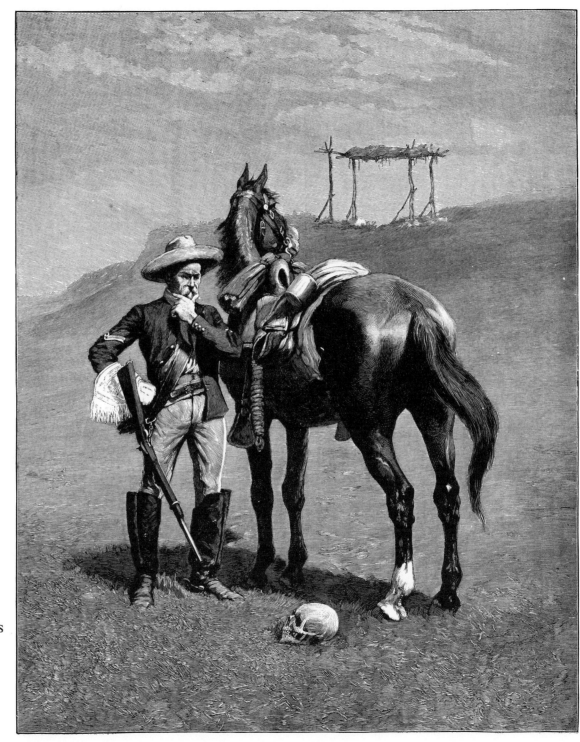

THE FRONTIER TROOPER'S THANATOPSIS

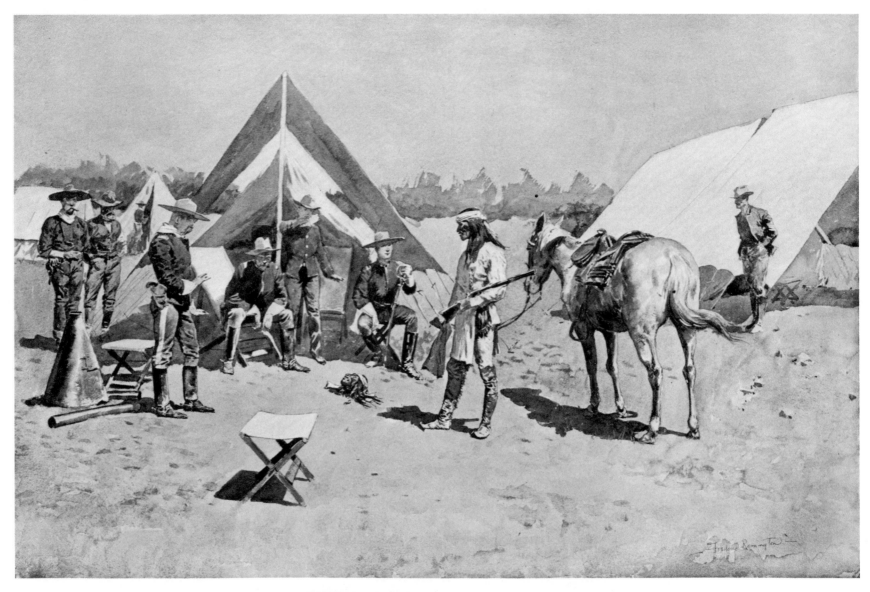

SATISFYING THE DEMANDS OF JUSTICE: THE HEAD

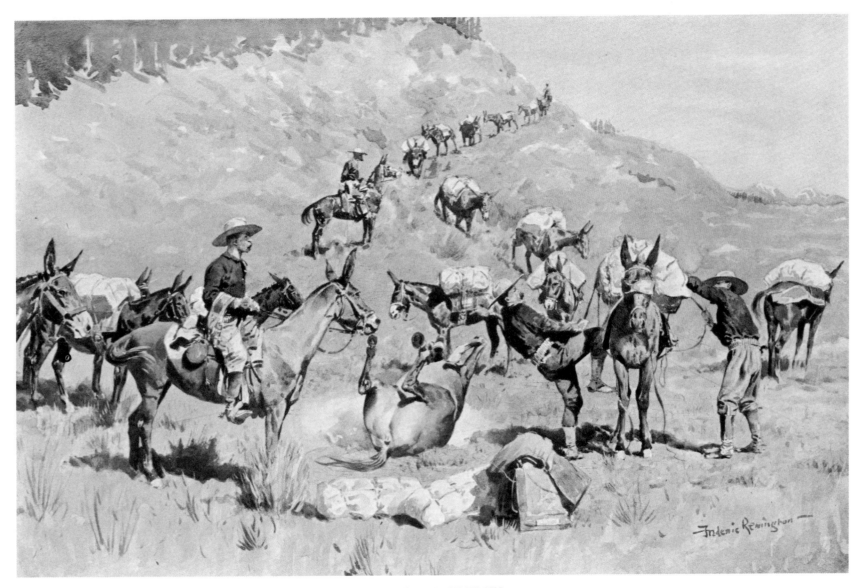

A GOVERNMENT PACK TRAIN

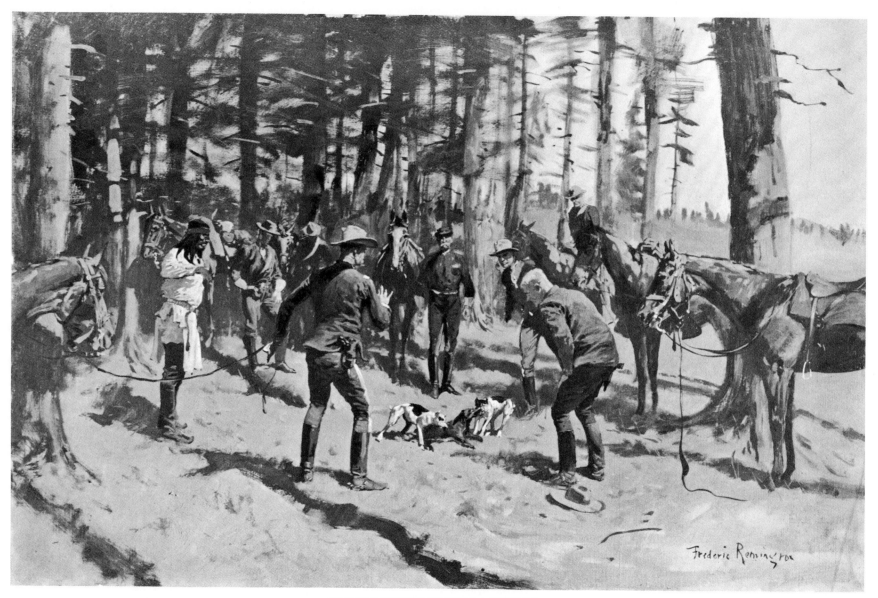

FOX TERRIERS FIGHTING A BADGER

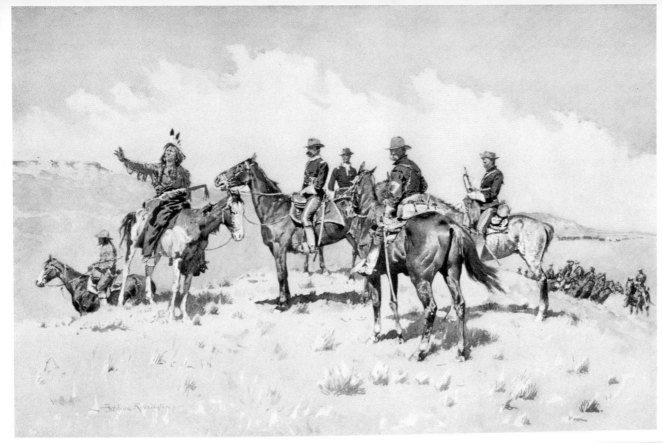

THE BORDERLAND OF THE OTHER TRIBE

THE WATER IN ARIZONA

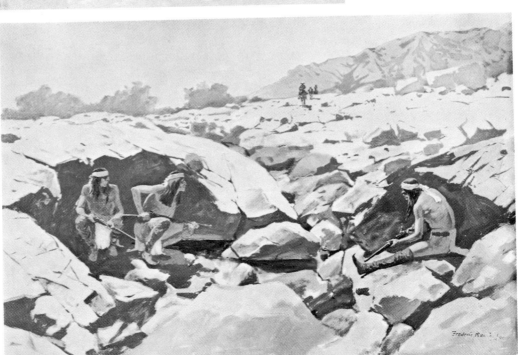

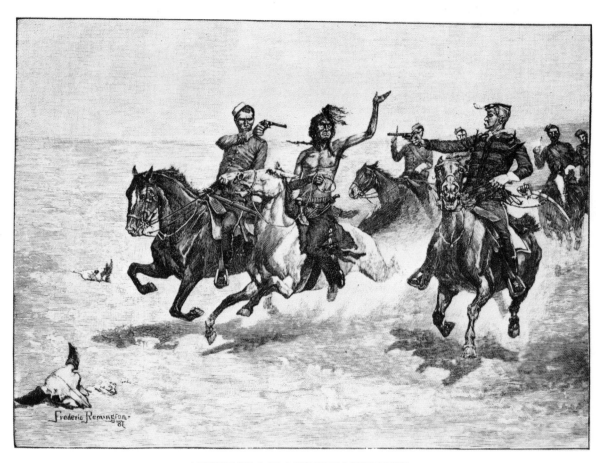

ARREST OF A BLACKFEET MURDERER

# Cowboys and Vaqueros

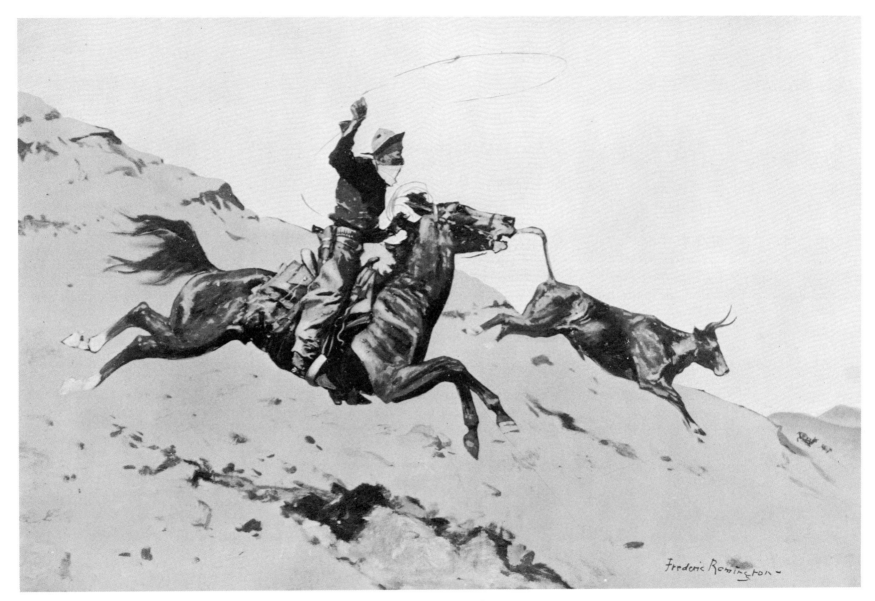

OVER THE FOOT-HILLS

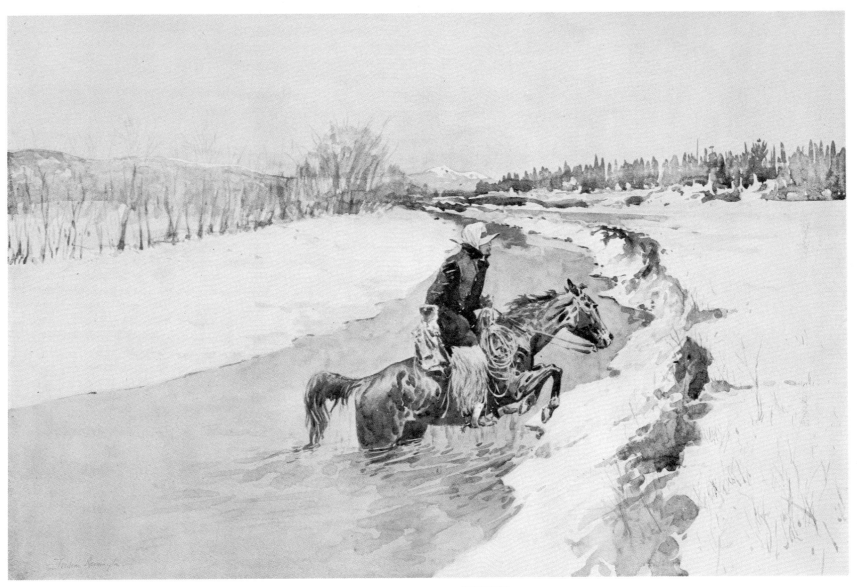

RIDING THE RANGE—WINTER

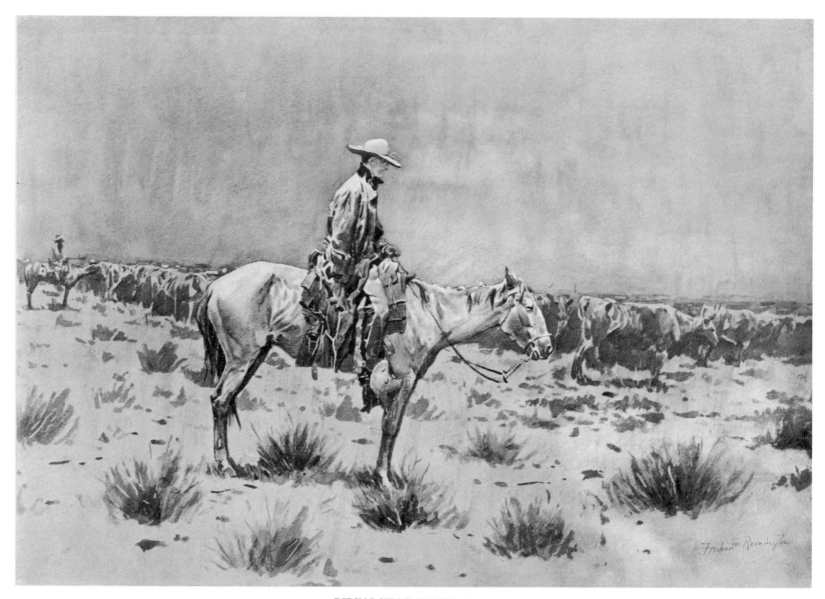

RIDING HERD IN THE RAIN

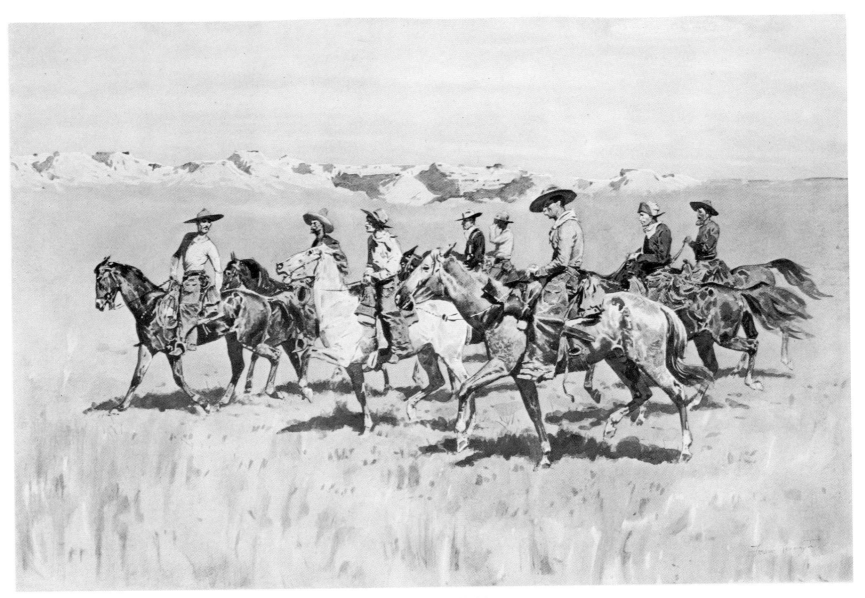

THE PUNCHERS

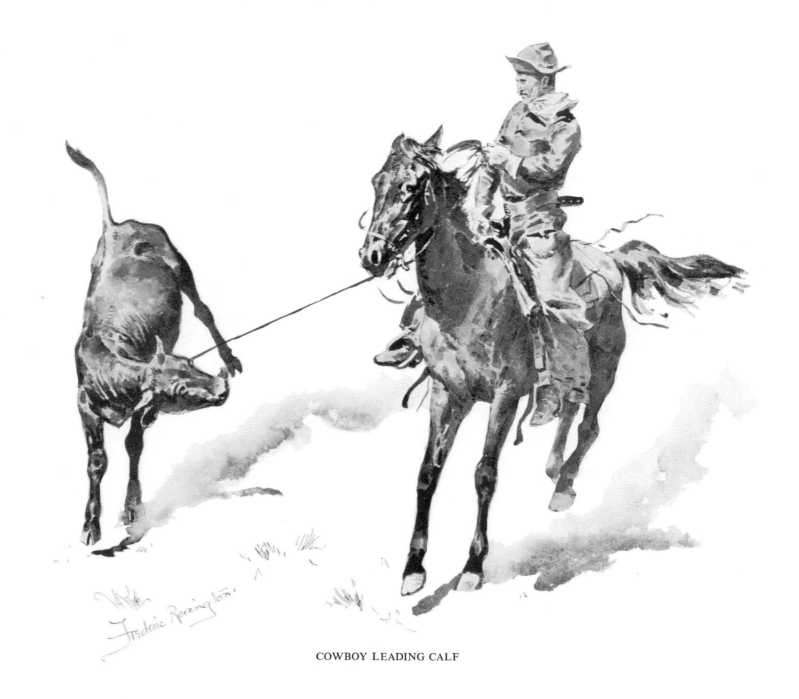

COWBOY LEADING CALF

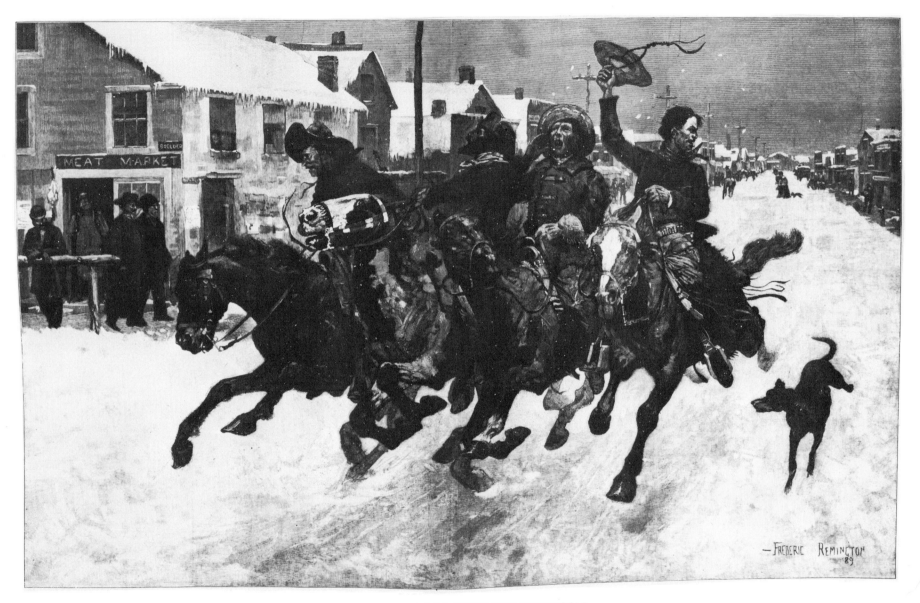

COWBOYS COMING TO TOWN FOR CHRISTMAS

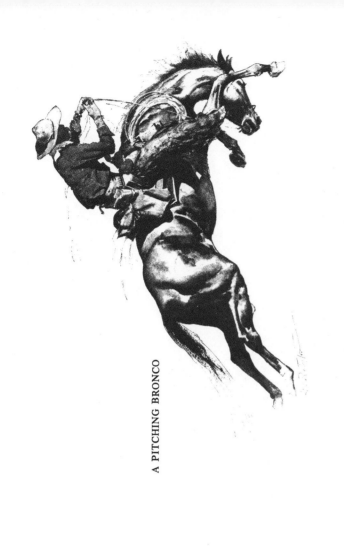

A PITCHING BRONCO

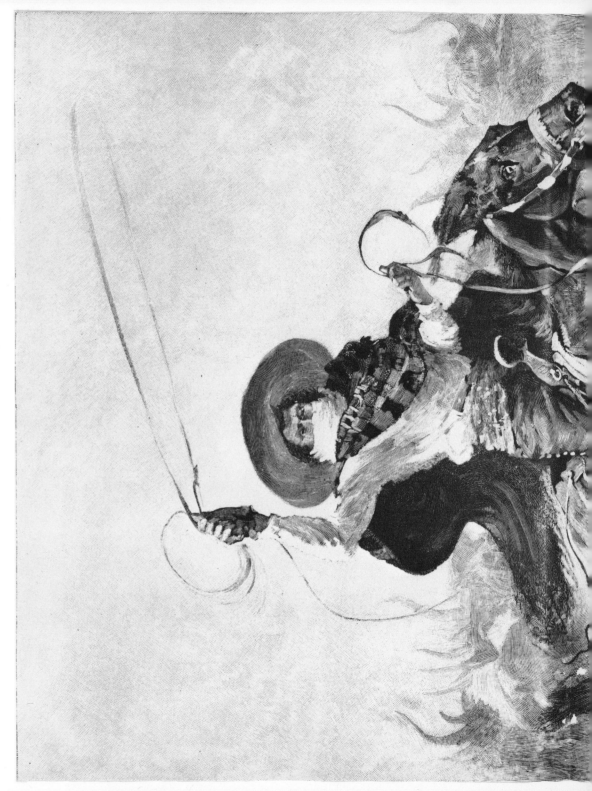

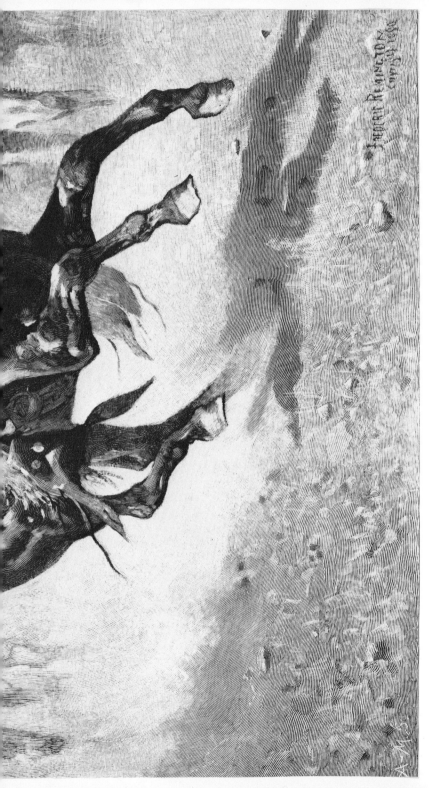

"TORO, TORO!"

SNAPPING A ROPE ON A HORSE'S FOOT

A SHATTERED IDOL

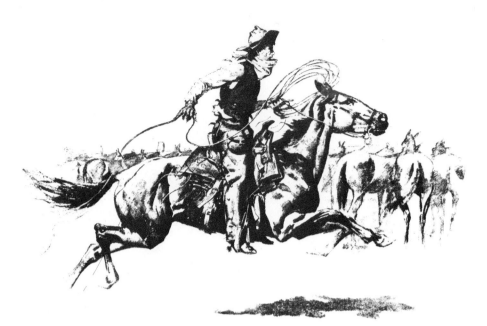

GATHERING THE ROPE

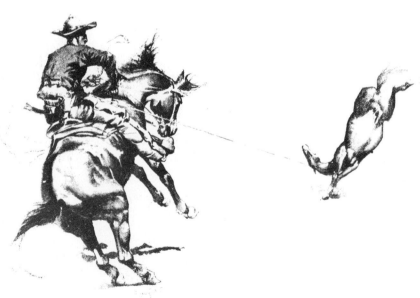

REACTION EQUALS ACTION

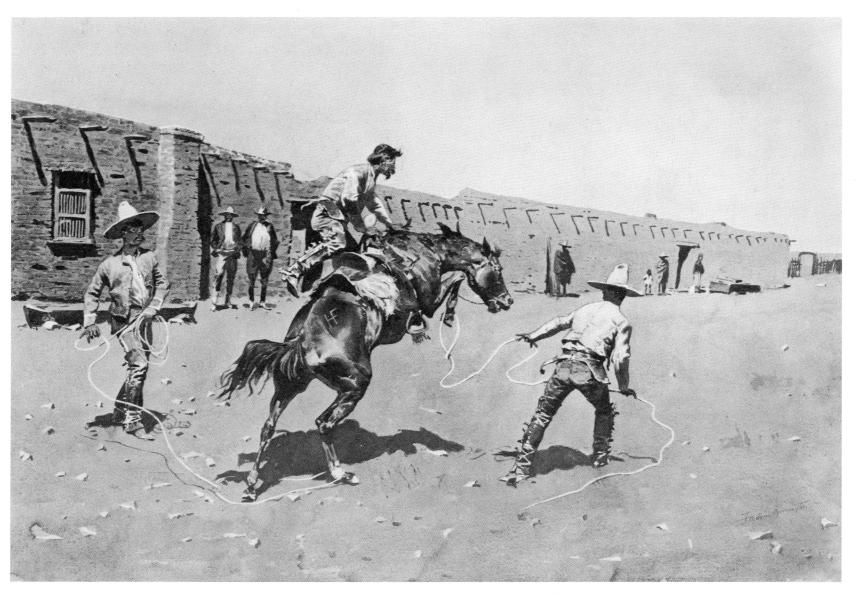

MEXICAN VAQUEROS BREAKING A "BRONC"

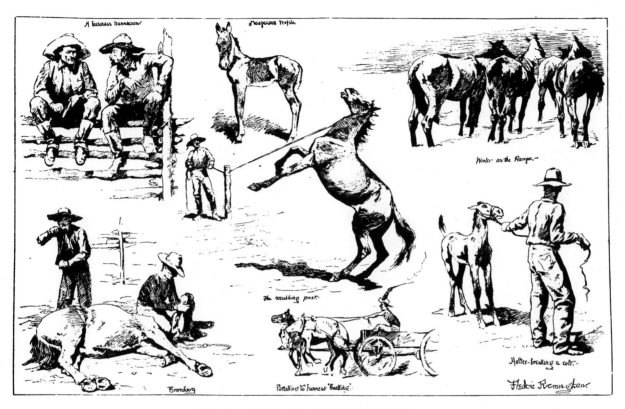

HORSE RAISING IN THE NORTHWEST

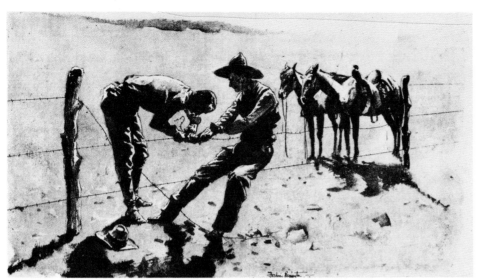

FIXING A BREAK IN THE WIRE FENCE

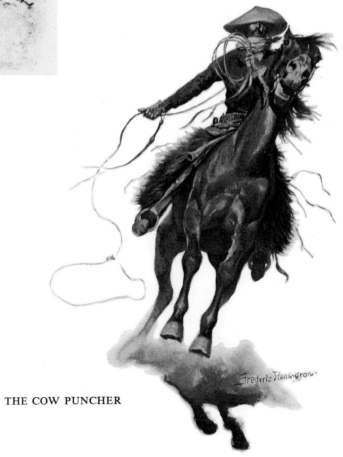

THE COW PUNCHER

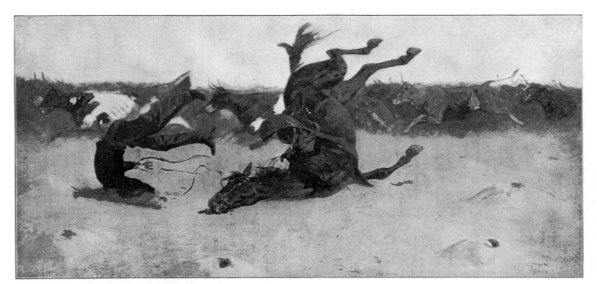

A LITTLE SUMMER SAULT

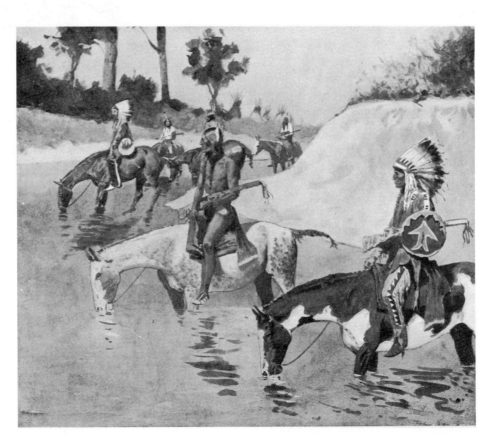

ON OKANOGAN'S BANKS

# Men in the Wilderness

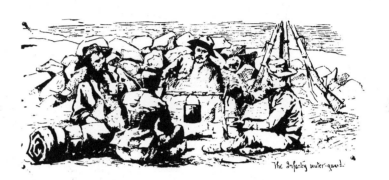

The Infantry water-guard

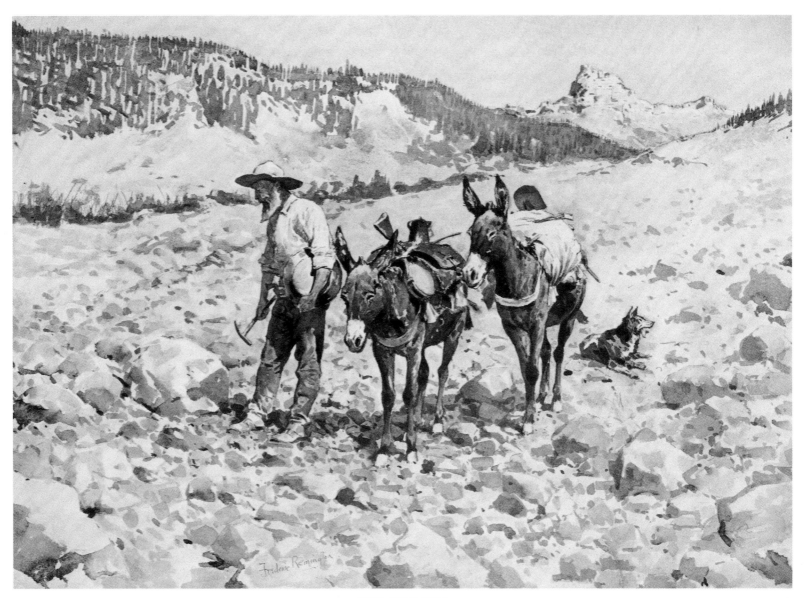

THE GOLD BUG

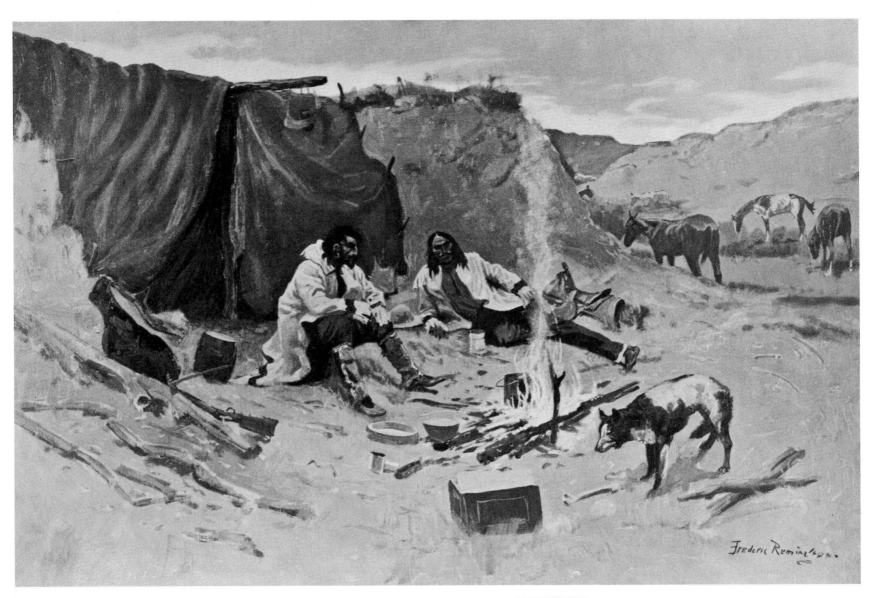

HALF-BREED HORSE THIEVES OF THE NORTHWEST

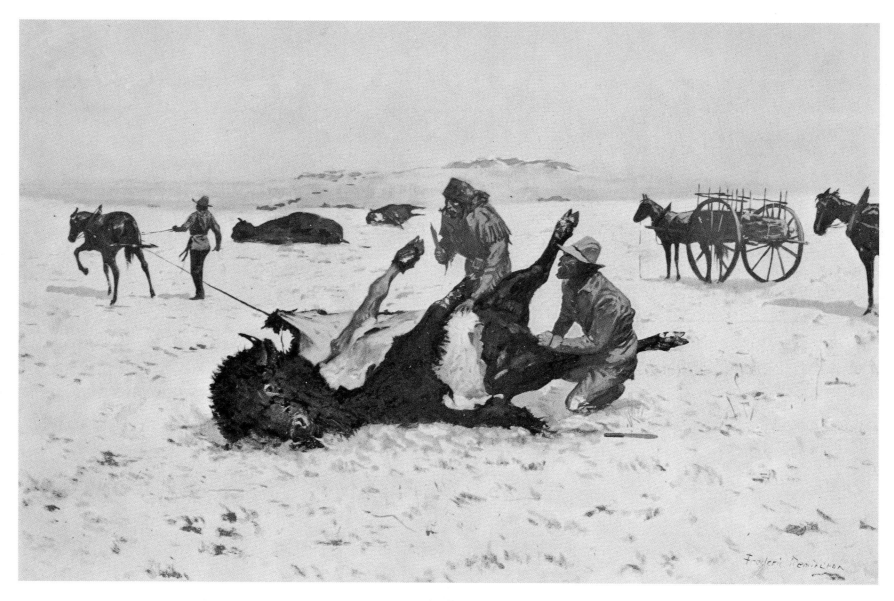

TAKING THE ROBE

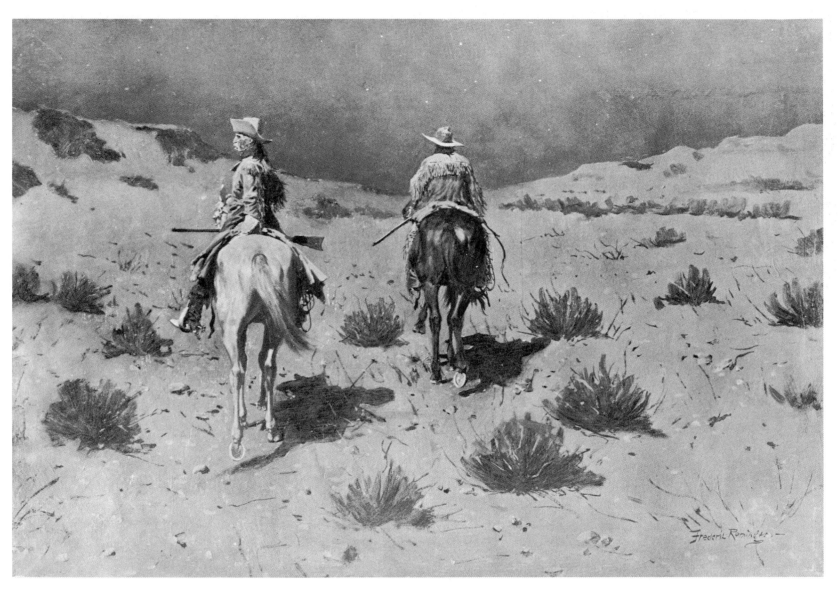

GOVERNMENT SCOUTS—MOONLIGHT

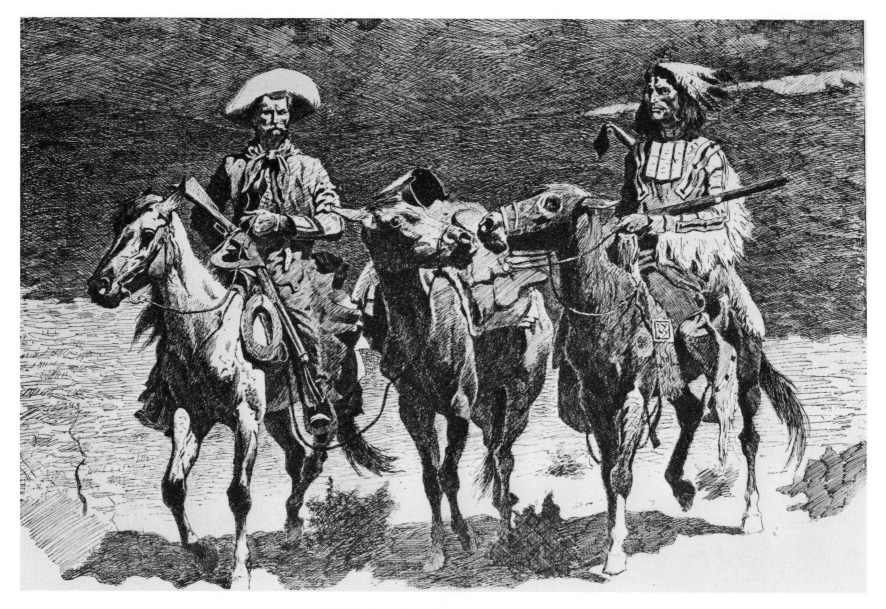

QUESTIONABLE COMPANIONSHIP

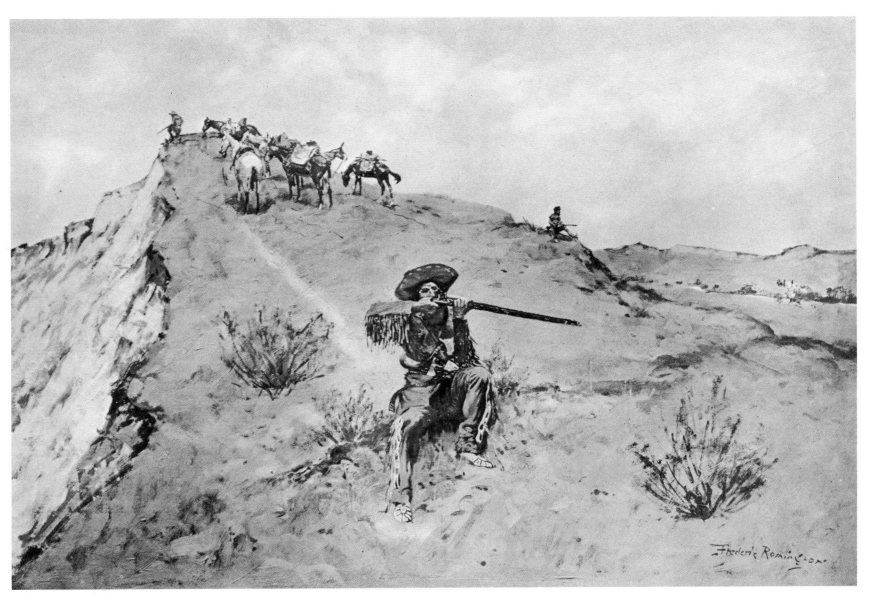

A CITADEL OF THE PLAINS

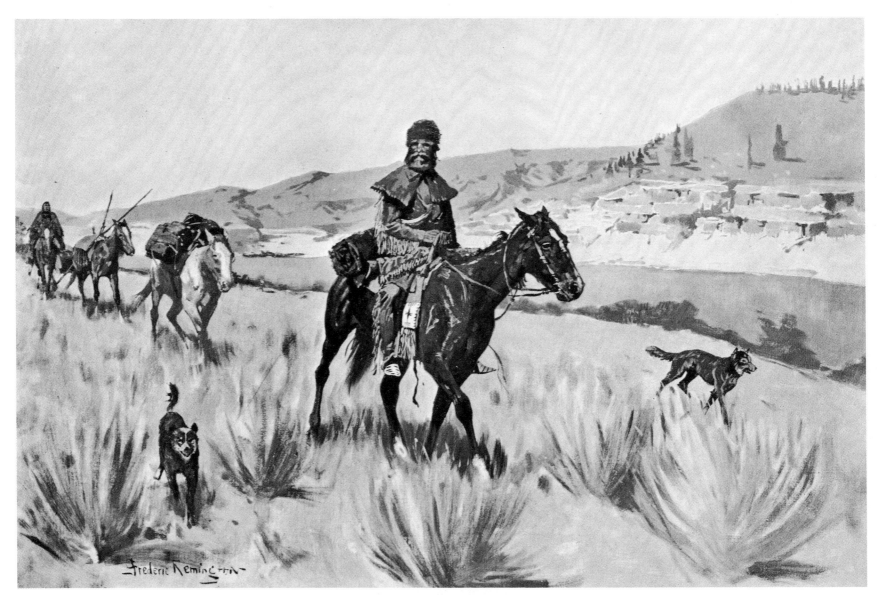

HUNTING A BEAVER STREAM—1840

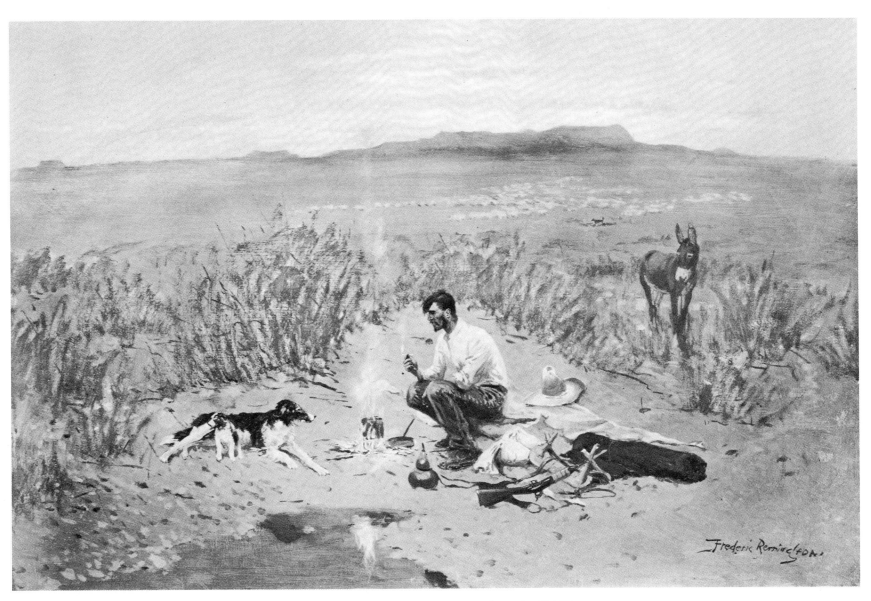

THE SHEEP HERDER'S BREAKFAST

# The Indian

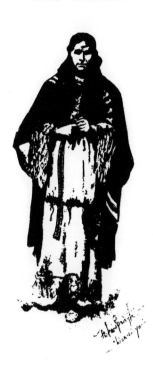

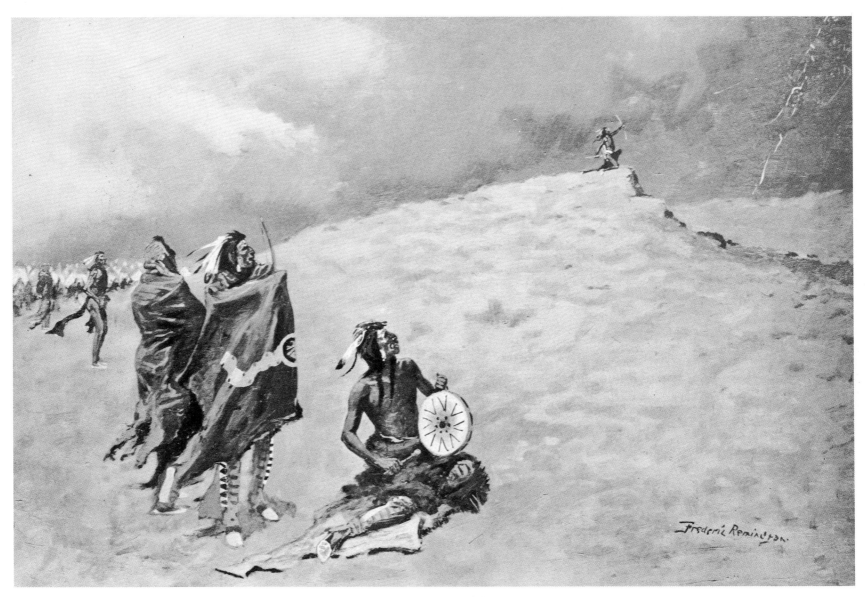

THE COMING STORM

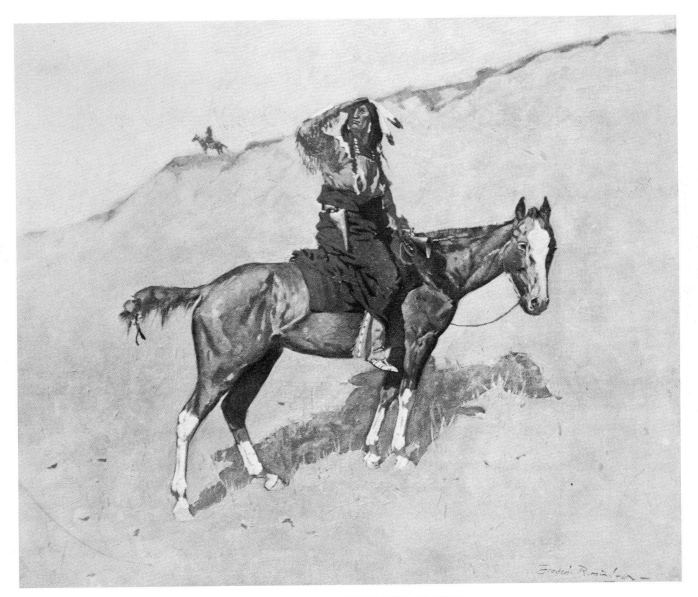

HOSTILES WATCHING THE COLUMN

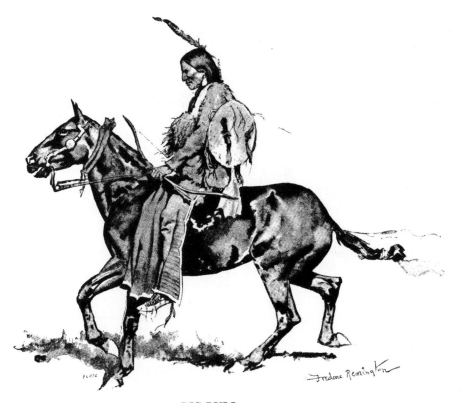

BIG BULL

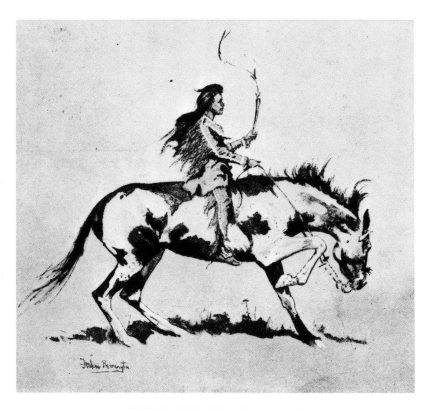

INDIAN BOY AND PINTO PONY

ILLUSTRATION USED FOR "LE COUREUR DE NEIGES," A CANADIAN LEGEND BY WILLIAM MC LENNON

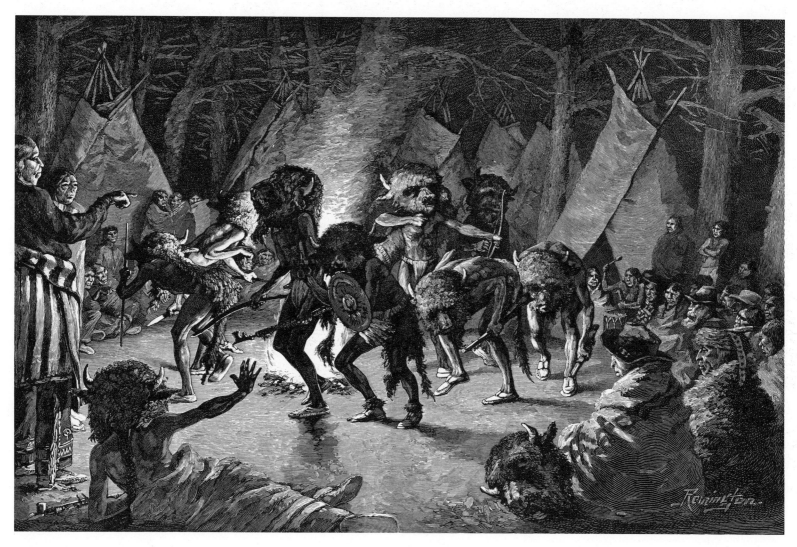

THE BUFFALO DANCE

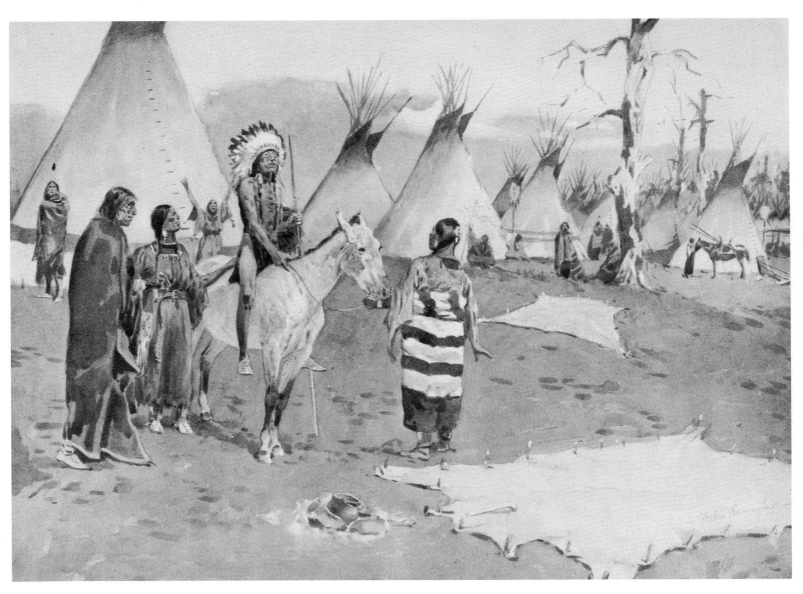

HIS DEATH SONG

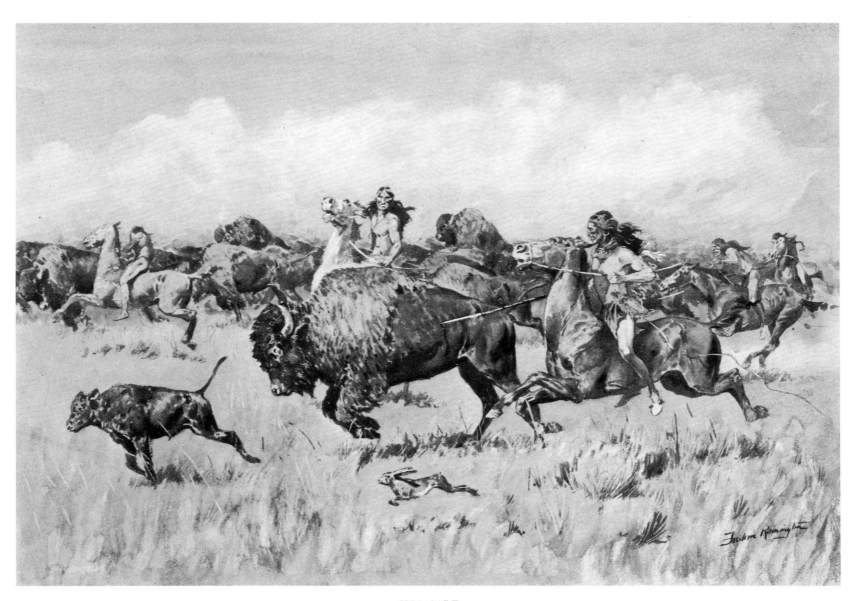

HER CALF

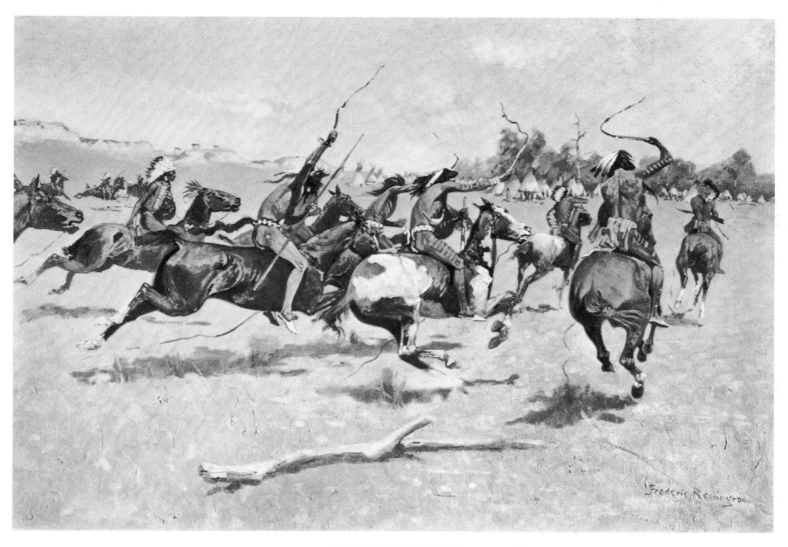

THE PONY WAR-DANCE

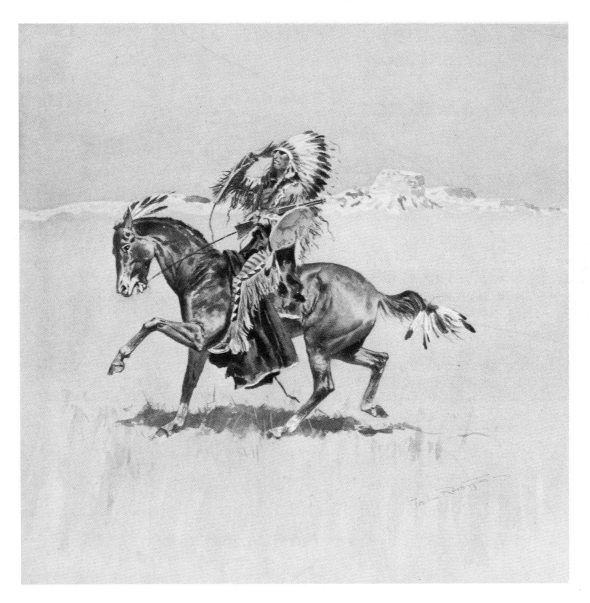

A CHEYENNE WARRIOR

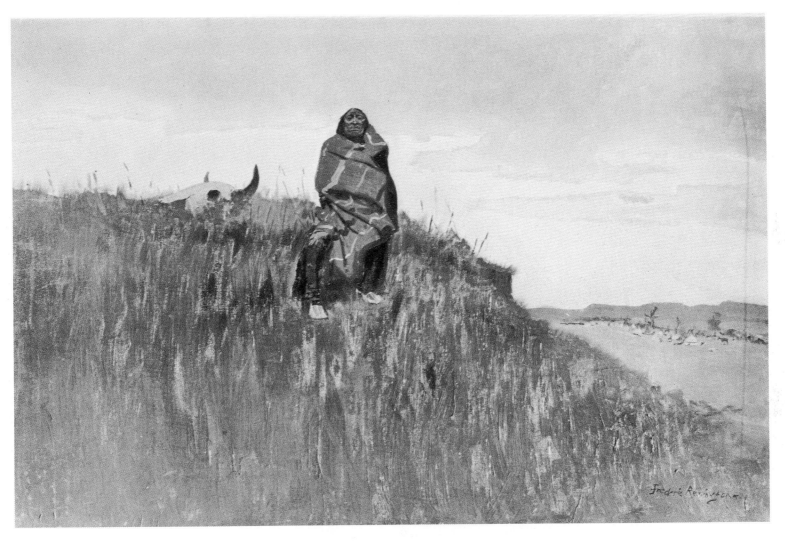

WHEN HIS HEART IS BAD

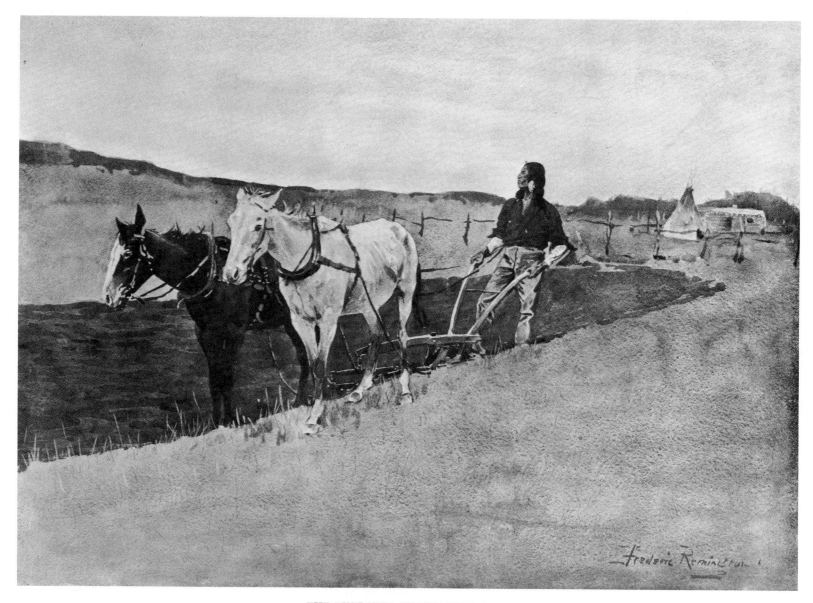

THE TWILIGHT OF THE INDIAN

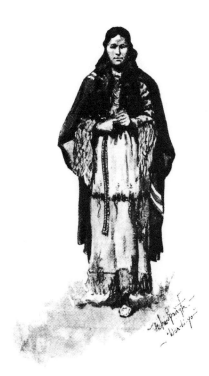

A KIOWA MAIDEN

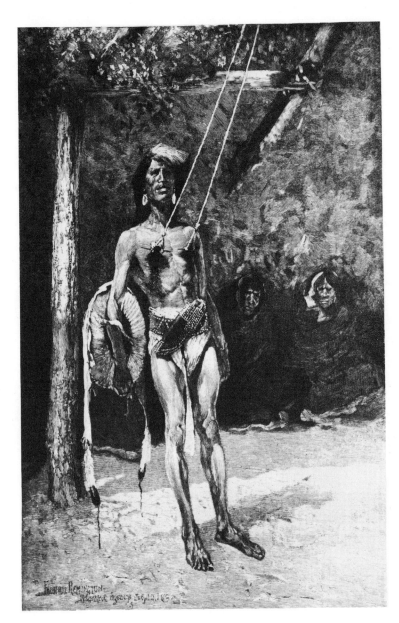

THE ORDEAL IN THE SUN DANCE AMONG THE BLACKFEET INDIANS

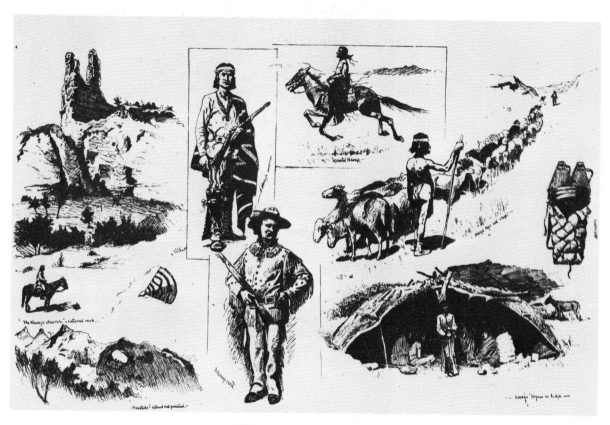

THE NAVAJO INDIANS

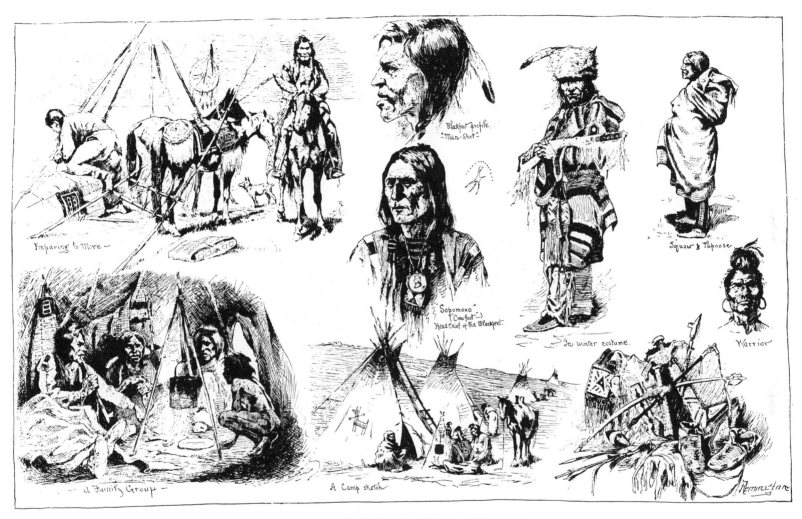

IN THE LODGES OF THE BLACKFEET INDIANS

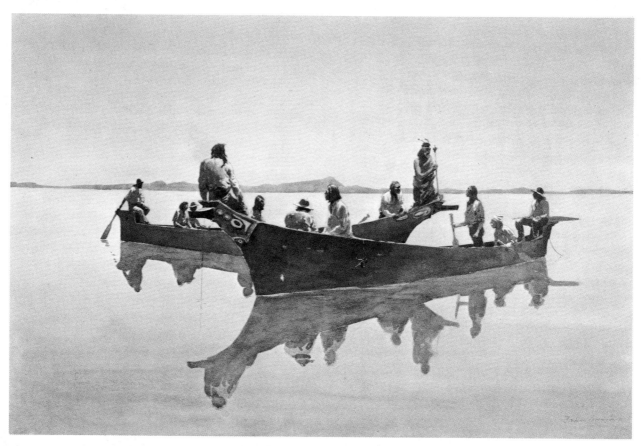

ON THE NORTHWEST COAST

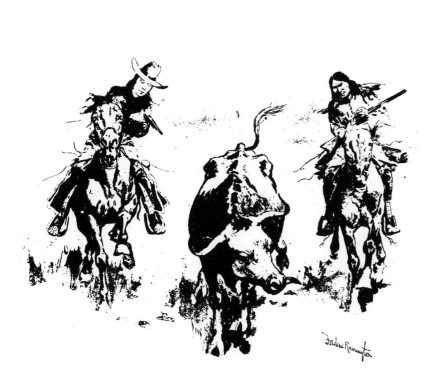

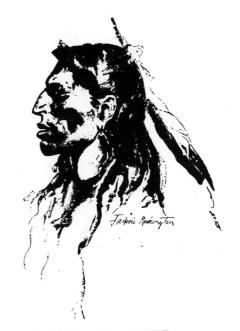

THE CHEYENNE TYPE

THE BEEF ISSUE AT ANADARKO

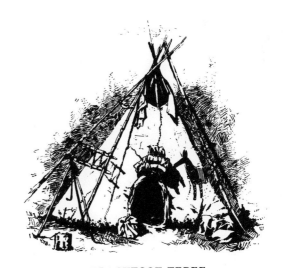

BLACKFOOT TEPEE

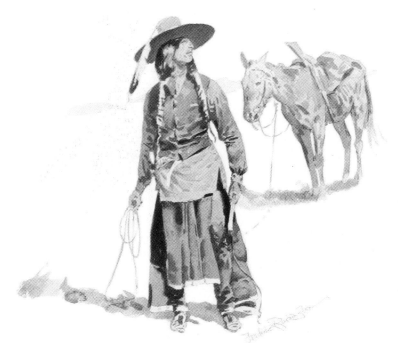

NEZ PERCÉ INDIAN

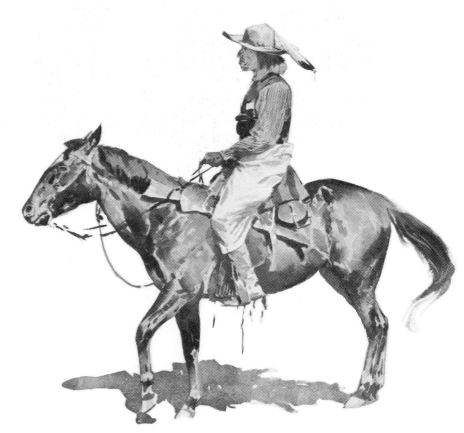

A RESERVATION INDIAN

192